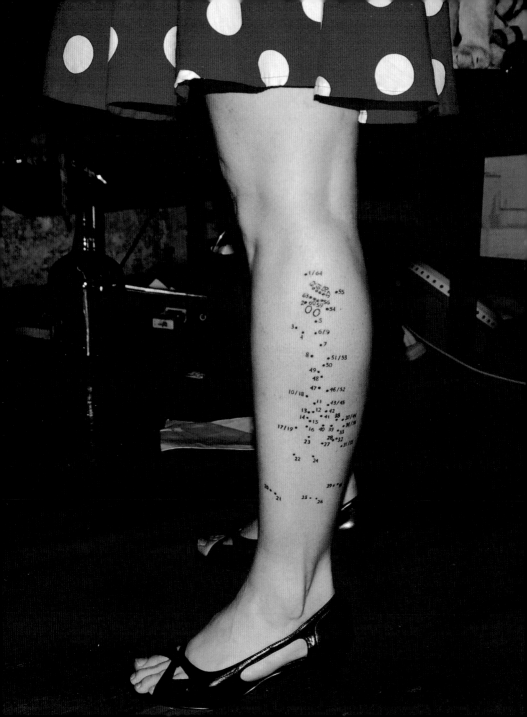

INTRODUCTION

In an age of standardization, tattoos are one of the few areas where individuality still reigns. Every tattoo in this book tells a unique story. The narrative can be anything from a smutty quip to an elaborate epic in many parts. As a reader, your reactions to these epidermal enhancements will vary. You'll feel admiration, envy, or even bewilderment. One thing is certain, you're unlikely to browse this collection without feeling *something*.

Intimate in their scale and scope, these messages reside on the most personal of all mediums—the human body. It takes bravery to commit to a tattoo. And, unlike other forms of art, there's far less room for error. A whim becomes an eternal declaration; a smudged detail you'll just have to live with. Time marches on, and tattoos stick around. Like any affair of the heart, there's a distinct possibility for regret. Will you always love your inky companion, or will your folly taunt you in years to come? Only the years will tell.

Tattoos call out for comment. Whether visible in broad daylight, or only when the lights are low, a tattoo is made for display. Some are direct like a catcall. Others tell the most obtuse of insider jokes, a sly reference for the initiated few. And, there's frequently a back-story, if you ask.

We connect strongly with our tattoos. Unlike other works of art, they are always created while you're in the room. And the bond grows deeper over time. Like a faithful pet or an annoying roommate, they're always *there*. Once they're paid for, they can't be traded or sold. A distinctly old-fashioned concept of bespoke creation, tattoos allow everyday people to commission a masterpiece.

So what makes a tattoo outstanding? Like most great art, beauty is often secondary. Originality has something to do with it. A theatrical flourish always helps. A sense of humor and wit is appreciated. Craftsmanship and attention to detail are key. Whether adding distinction to your collarbone or derrière, like real estate, location wins points. Triumphant or tragic, our judgments will differ. But all the images showcased here are memorable. We thank all those who had the generosity—or the downright nerve—to share them with us.

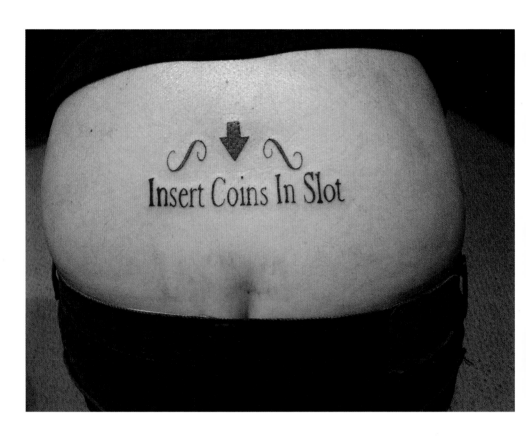

Im Zeitalter der Standardisierung gehören Tätowierungen zu den wenigen Gebieten, auf denen noch Individualität herrscht. Jede Tätowierung in diesem Buch erzählt eine einzigartige Geschichte. Diese kann alles sein, von einer schmutzigen Anmerkung bis hin zu einem Epos in mehreren Teilen. Die Reaktionen des Lesers auf diese epidermalen Erweiterungen werden unterschiedlich sein. Er wird Bewunderung, Neid oder sogar Verwirrung verspüren. Eines ist sicher, er wird diese Sammlung wohl kaum durchblättern, ohne irgendetwas zu fühlen.

Diese Botschaften befinden sich auf dem persönlichsten aller Träger – dem menschlichen Körper – und sind dadurch limitiert, was ihre Größe und ihren Gehalt betrifft. Es bedarf Mut, zu einer Tätowierung zu stehen. Im Gegensatz zu anderen Kunstformen kann man sich keine Fehlversuche leisten. Aus einer Laune entsteht eine verewigte Aussage, ein verschmiertes Detail, mit dem man einfach leben muss. Die Zeit schreitet voran, aber Tätowierungen bleiben. Wie bei jeder Herzensangelegenheit besteht die Gefahr der späten Reue. Wird man seinen tintenschwarzen Partner für immer lieben oder wird man wegen seiner eigenen Narrheit in künftigen Jahren verhöhnt werden? Allein die Zeit wird es zeigen.

Tätowierungen schreien regelrecht nach Kommentaren. Ob man sie am helllichten Tage sieht oder nur bei Dunkelheit, eine Tätowierung ist zum Vorzeigen gemacht. Einige sind schreiend direkt. Andere erzählen die stumpfsten Insider-Witze, versteckte Hinweise für wenige Eingeweihte. Und es gibt häufig eine Hintergrundgeschichte, wenn man nachfragt.

Wir gehen mit unseren Tätowierungen eine enge Bindung ein. Und die Bindung wächst mit der Zeit. Tattoos sind immer da, wie ein treues Haustier oder ein nerviger Mitbewohner. Als direkte, altbewährte Form von maßgeschneidertem Design ermöglichen Tätowierungen es dem Durchschnittsbürger, ein Meisterwerk in Auftrag zu geben.

Was macht also eine Tätowierung besonders? Wie meistens bei großer Kunst ist die Schönheit zweitrangig. Es kommt eher auf Originalität an. Hier noch eine Verzierung, dort noch ein Schnörkel. Sinn für Humor und ein bisschen Ironie sind angebracht, Handwerkszeug und Liebe zum Detail unerlässlich. Triumphal oder tragisch, die Beurteilungen werden unterschiedlich sein. Aber alle Bilder, die hier präsentiert werden, sind unvergesslich. Wir danken all jenen, die die Großzügigkeit – buchstäblich die Nerven – dazu hatten, sie mit uns zu teilen.

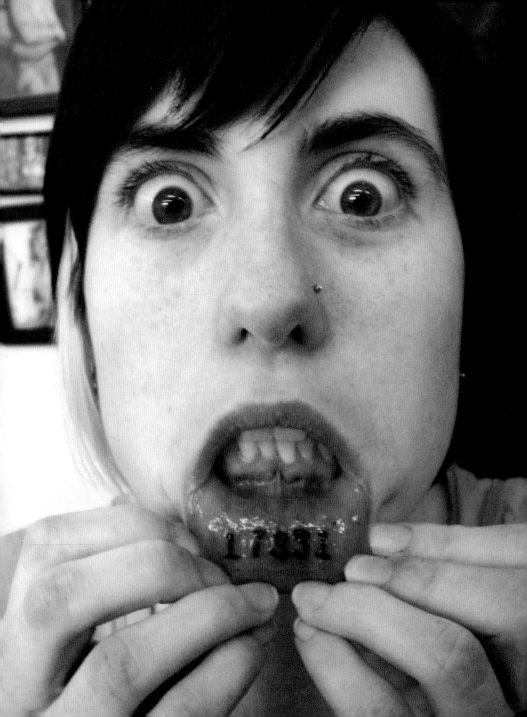

En ces temps d'uniformisation, les tatouages restent un des rares domaines où règne encore l'individualité. Chaque tatouage présenté dans ce livre raconte une histoire unique à travers tous les genres possibles, des blagues cochonnes aux épopées complexes en plusieurs parties. En tant que lecteur, vos réactions à ces expressions épidermiques vont varier entre admiration, envie et perplexité. Une chose est sûre : il est bien improbable que vous feuilletiez cette collection sans ressentir quelque chose.

Intimes dans leur échelle et leur portée, ces messages s'inscrivent sur le support le plus personnel qui soit — le corps humain. Il faut du courage pour se lancer dans un tatouage. Et, à la différence d'autres formes d'art, la marge d'erreur est beaucoup plus réduite. Un coup de tête devient une déclaration éternelle, une petite bavure dont vous devrez vous accommodez. Le temps passe et les tatouages restent. Comme dans toutes les histoires sentimentales, il y a toujours la possibilité d'un regret. Aimerez-vous toujours votre compagnon encré, ou votre folie vous narguera-t-elle durant les années à venir ? Le temps seul le dira.

Les tatouages suscitent des commentaires. Qu'il soit visible en pleine lumière du jour, ou seulement lorsque la lumière est faible, un tatouage est fait pour être montré. Certains sont directs comme un sifflet. D'autres évoquent une blague tout à fait incompréhensible, une référence voilée réservée à quelques initiés. Il y a aussi souvent une histoire cachée, si vous posez des questions.

Nous sommes fortement attachés à nos tatouages. Contrairement à d'autres oeuvres d'art, ceux-ci sont toujours créés en notre présence. Et le lien s'approfondit avec le temps. Comme un chien fidèle ou un camarade de chambre ennuyeux, ils sont toujours là. Une fois payés, ils ne peuvent être échangés, ni vendus. Concept distinctement vieux jeu de création sur mesure, les tatouages permettent à tout un chacun de commander un chef d'oeuvre.

Alors, qu'est-ce qui rend un tatouage mémorable ? Comme dans le grand art en général, la beauté est souvent secondaire. L'originalité a un rôle à jouer. Une fioriture théâtrale est toujours utile. Les traits d'humour et d'esprit sont appréciés. Le savoir-faire et la minutie sont essentiels. Qu'il s'agisse de mettre en valeur votre clavicule ou votre derrière, comme dans l'immobilier, l'emplacement peut faire gagner des points. Triomphants ou tragiques, nos jugements vont varier. Mais toutes les images exposées ici sont mémorables. Nous remercions tous ceux qui ont eux la générosité — ou le culot — de nous les faire partager.

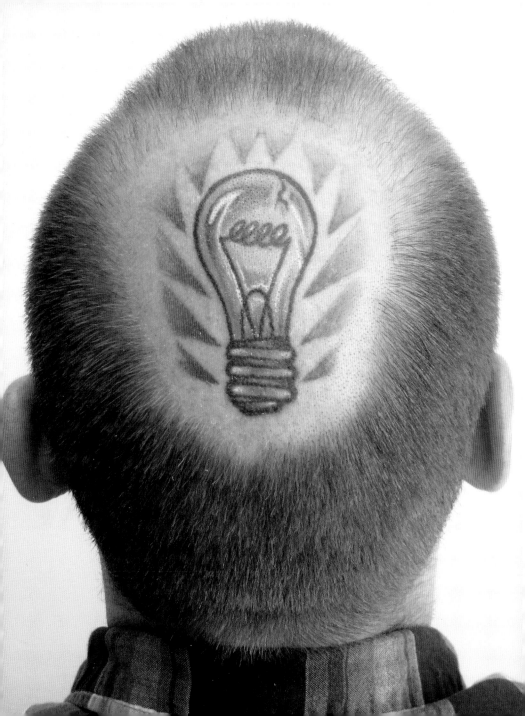

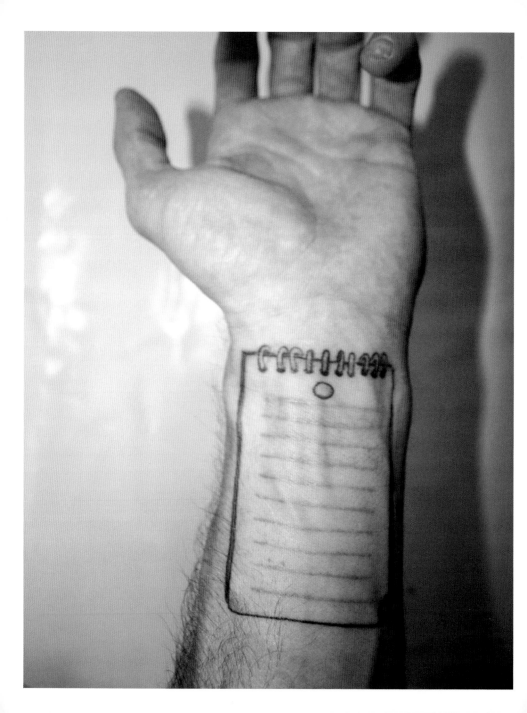

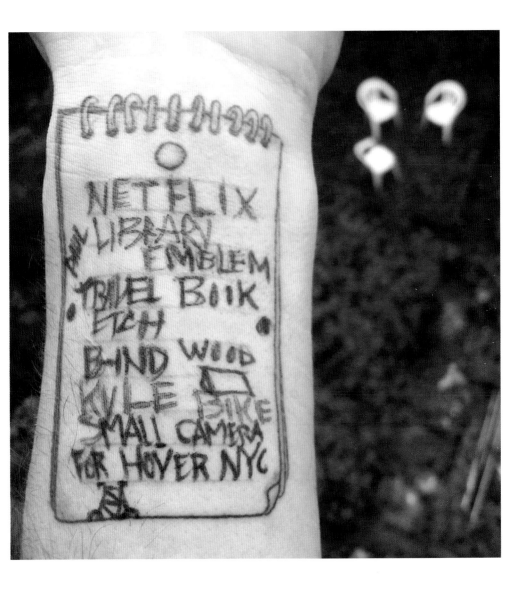

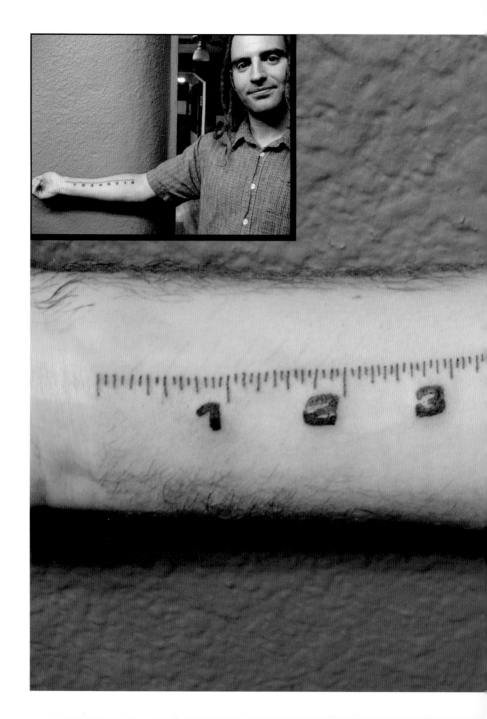

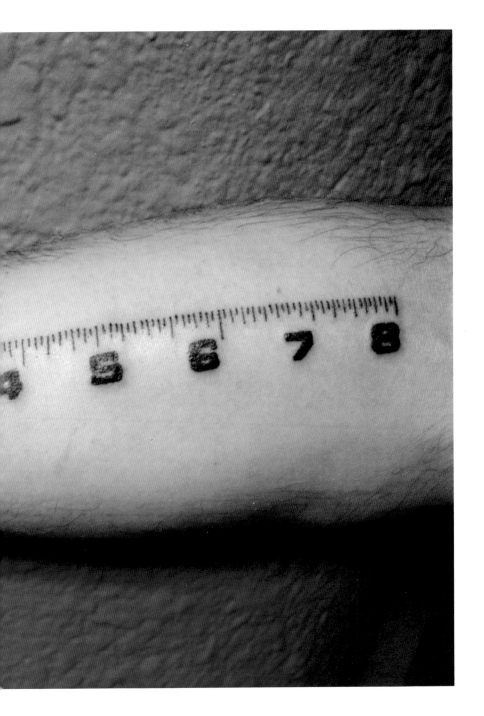

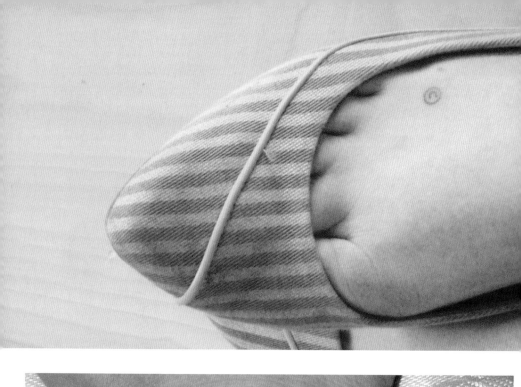
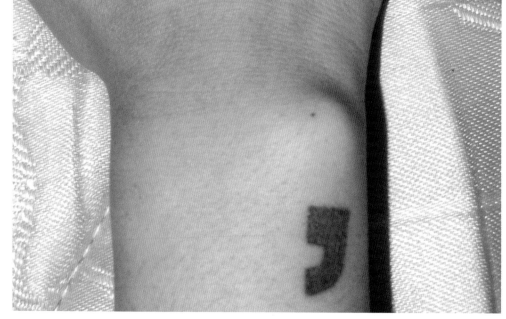

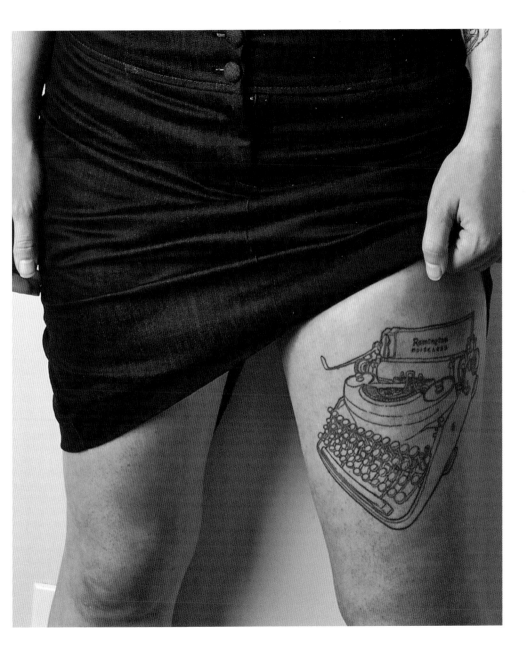

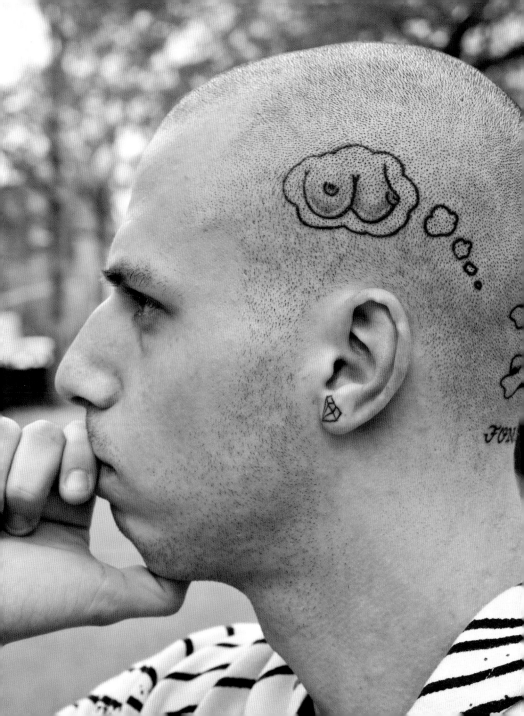

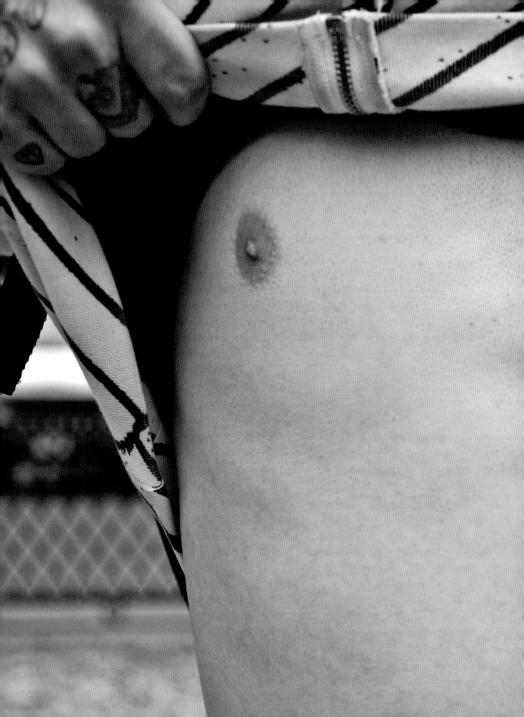

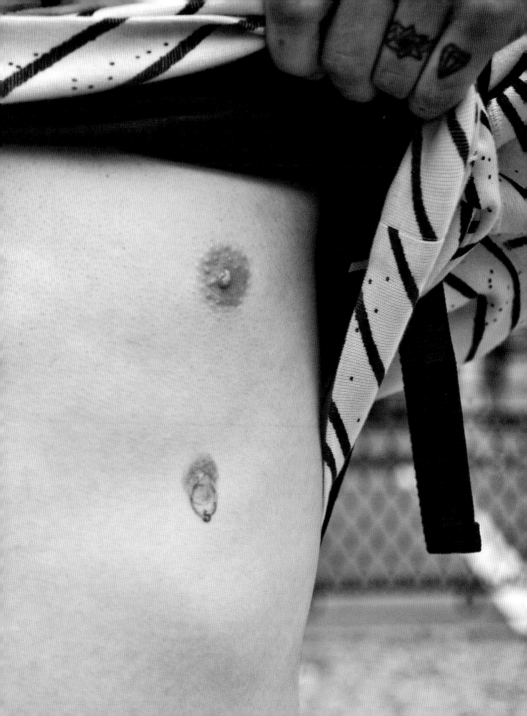

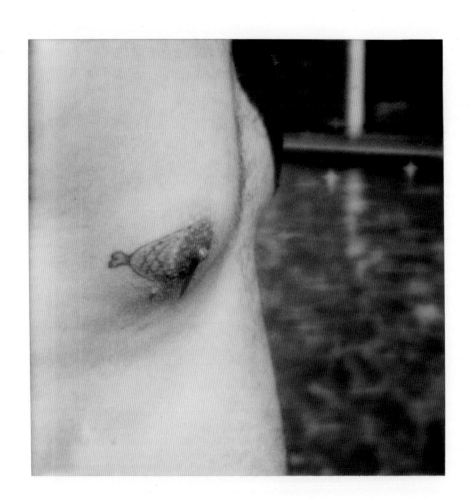

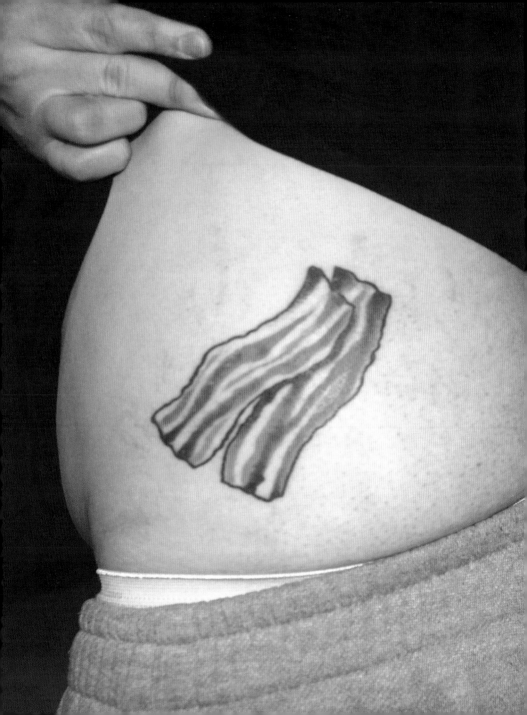

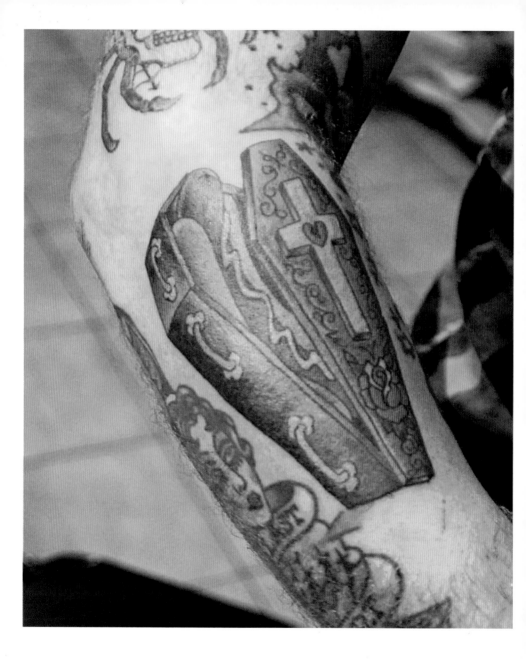

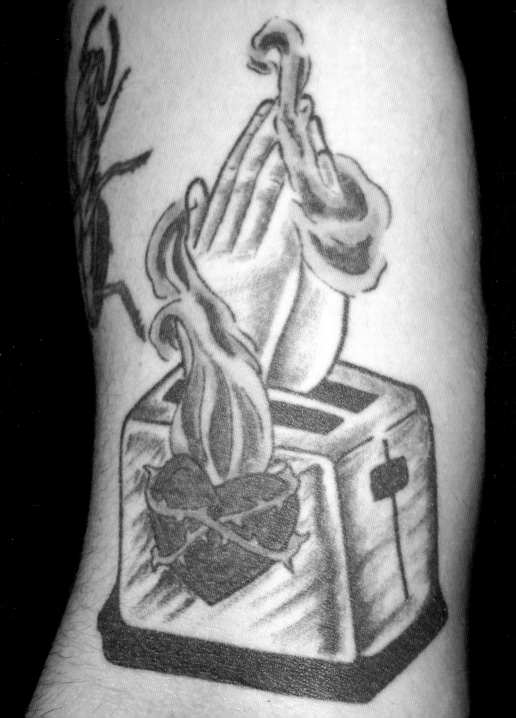

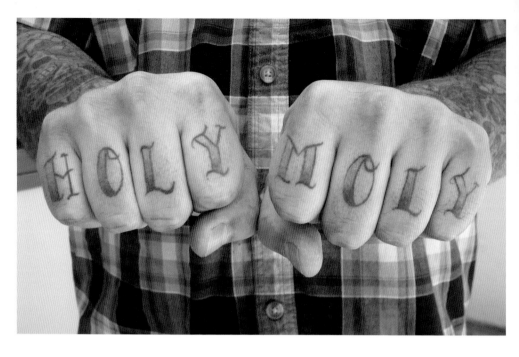

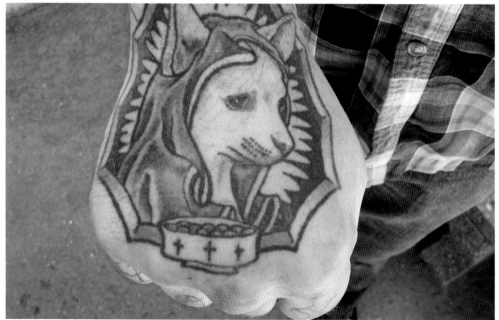

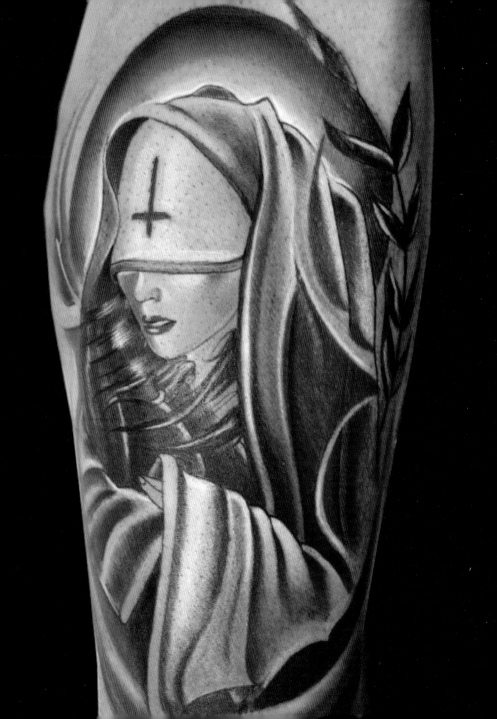

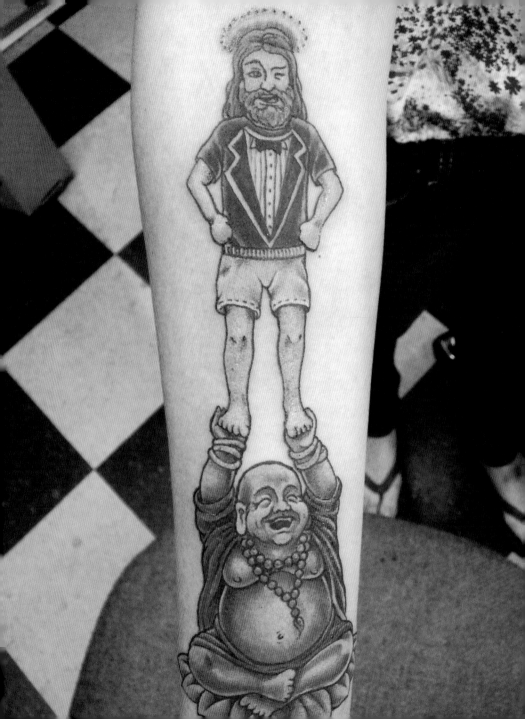

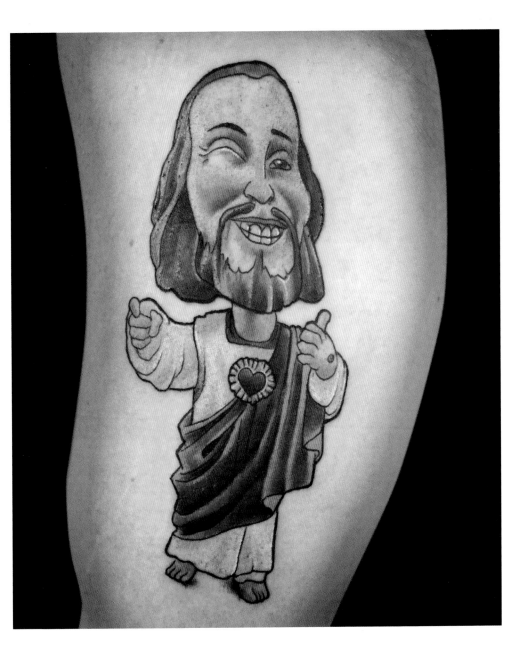

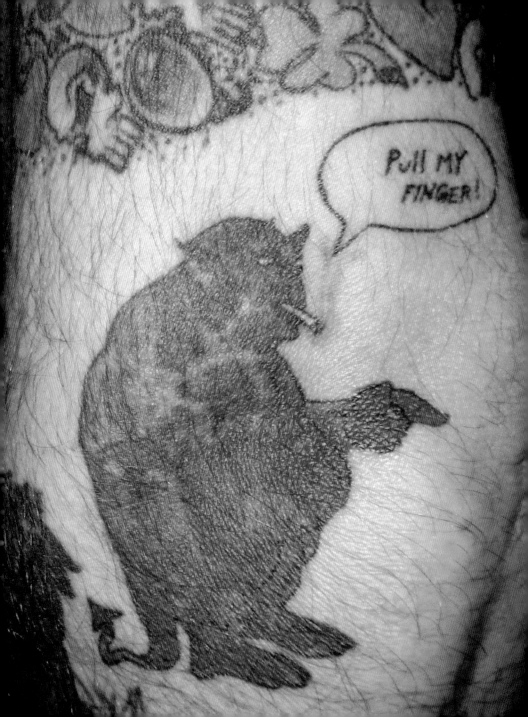

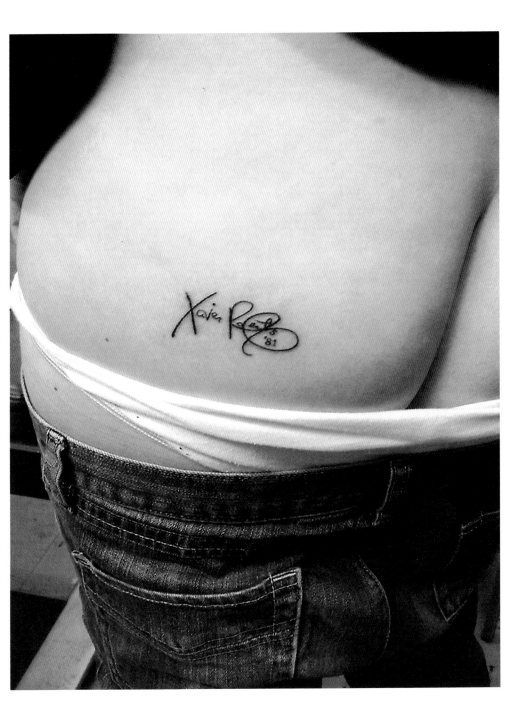

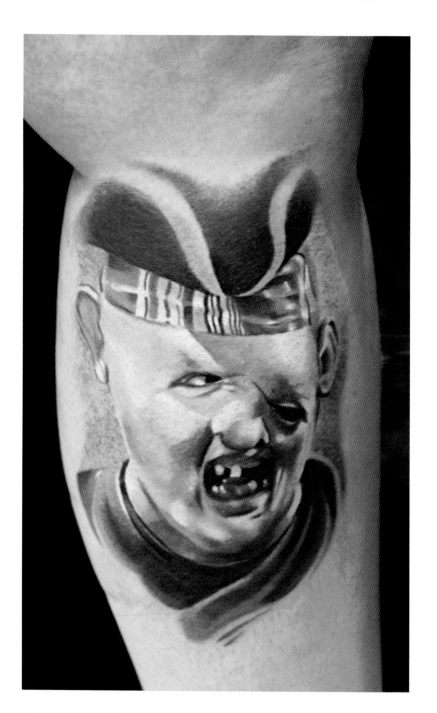

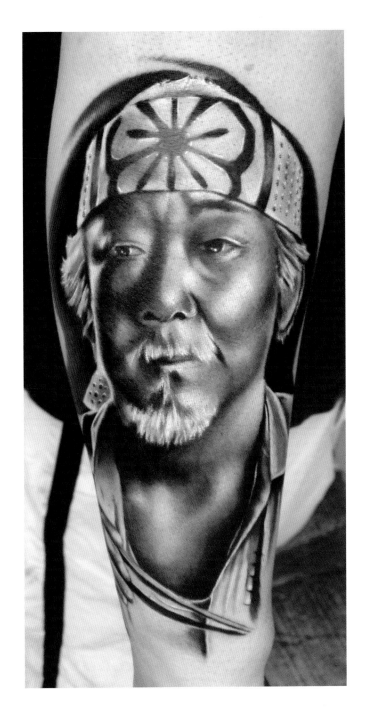

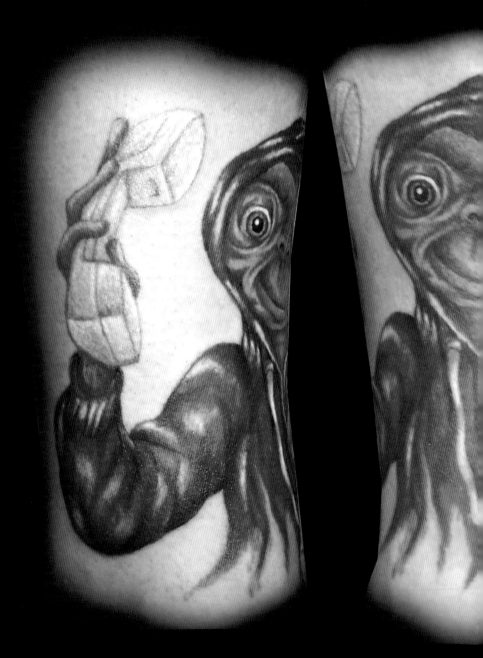

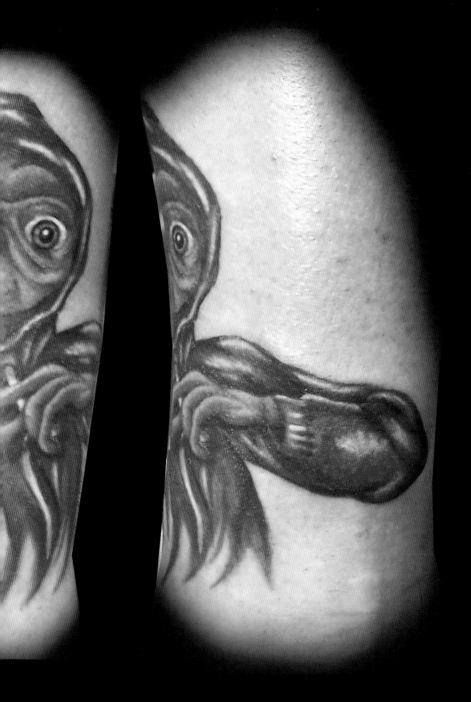

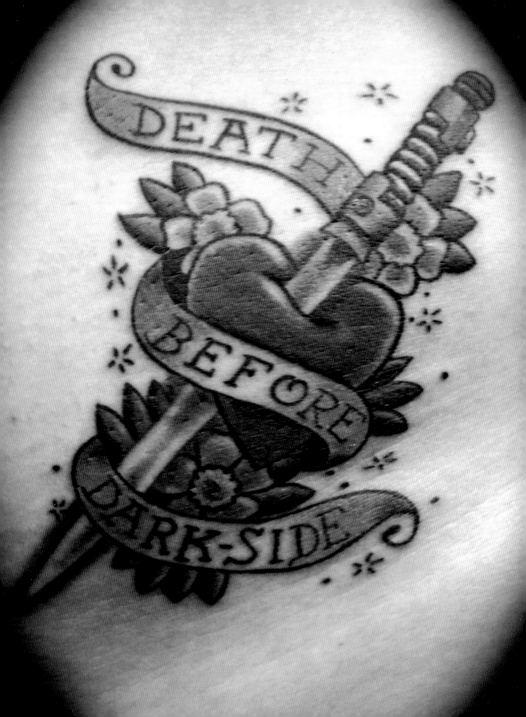

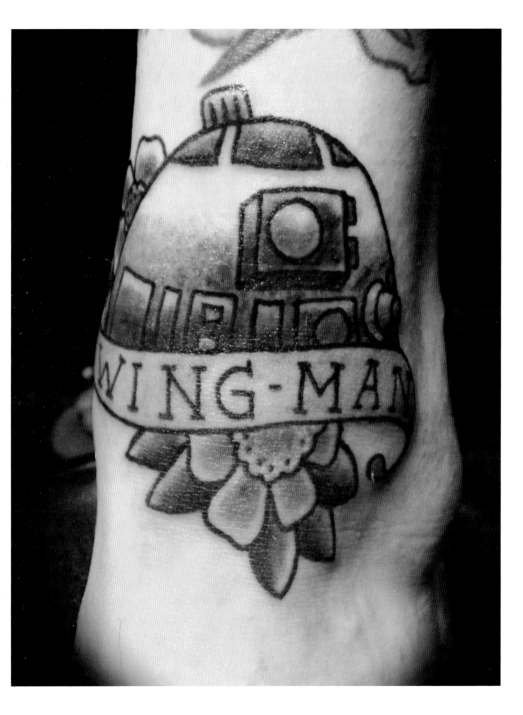

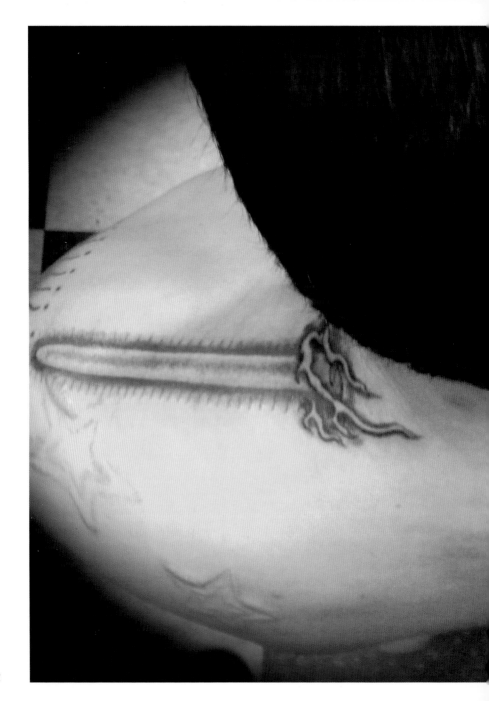

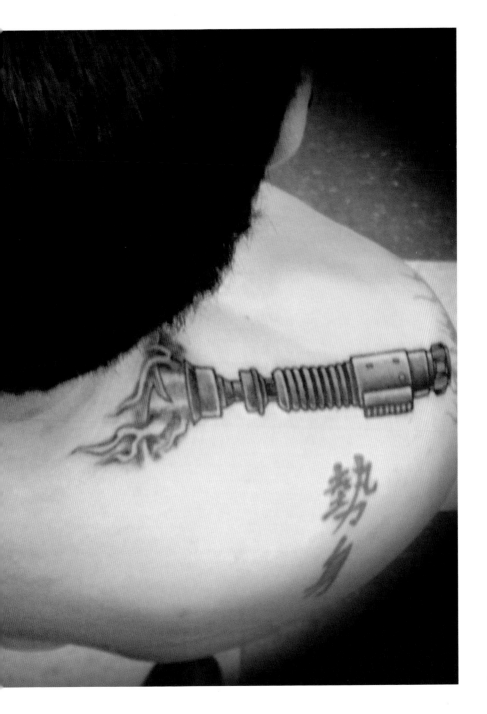

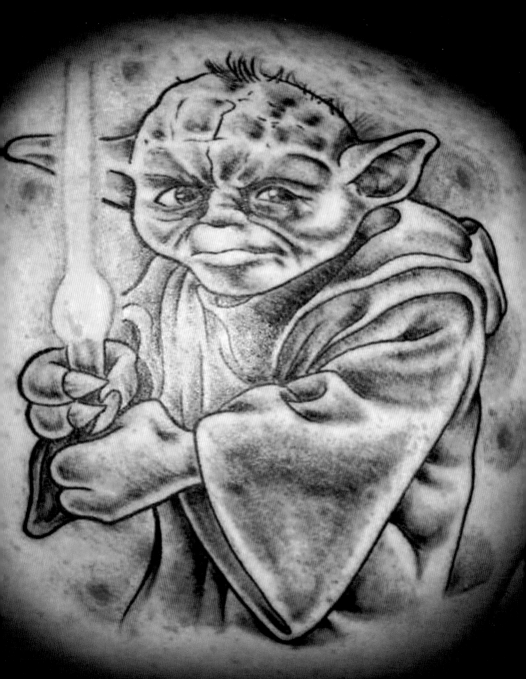

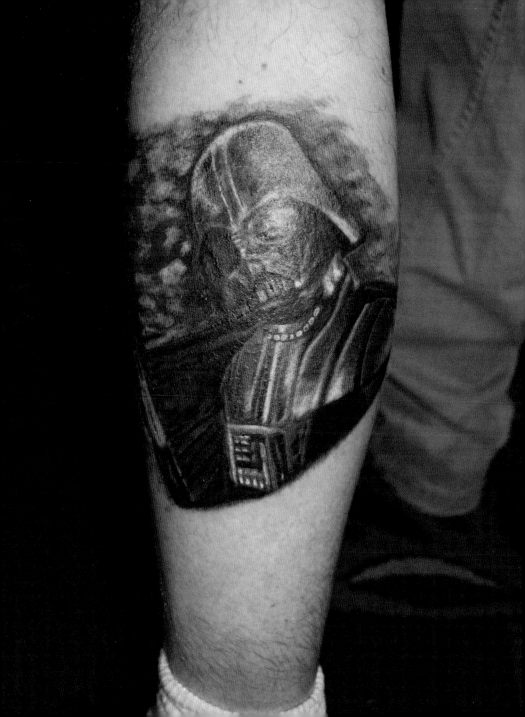

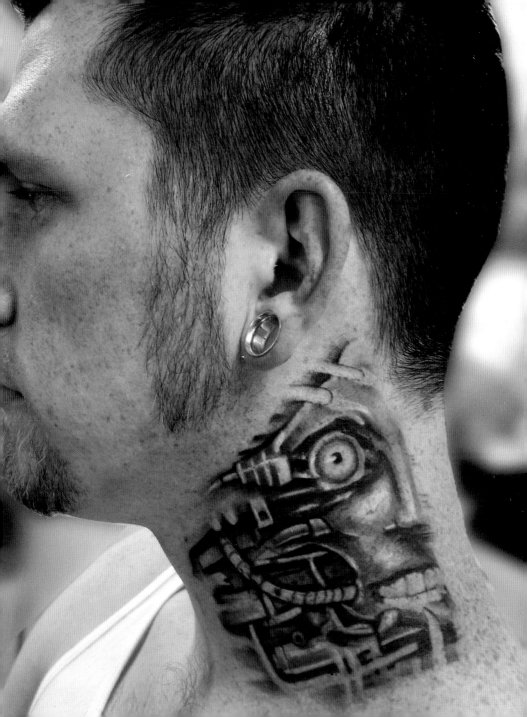

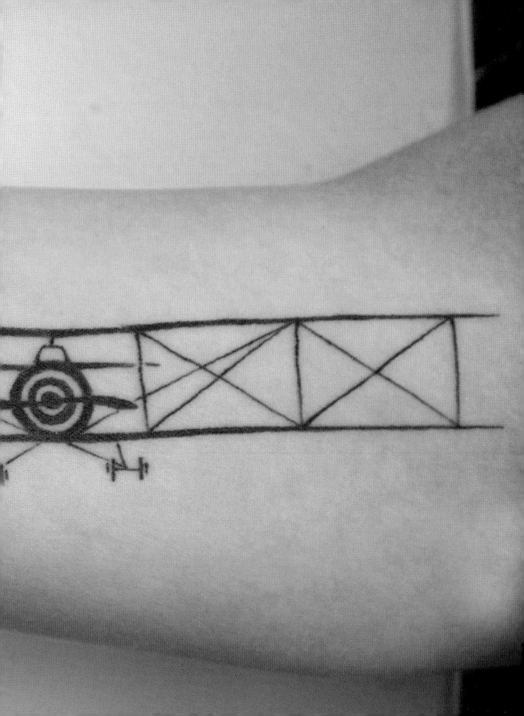

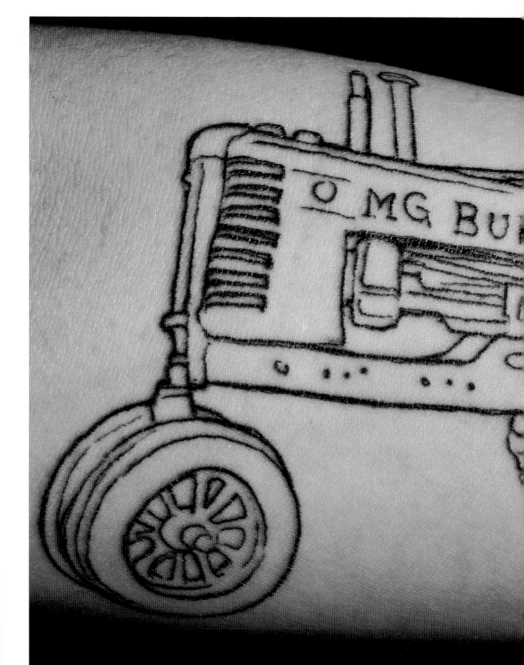

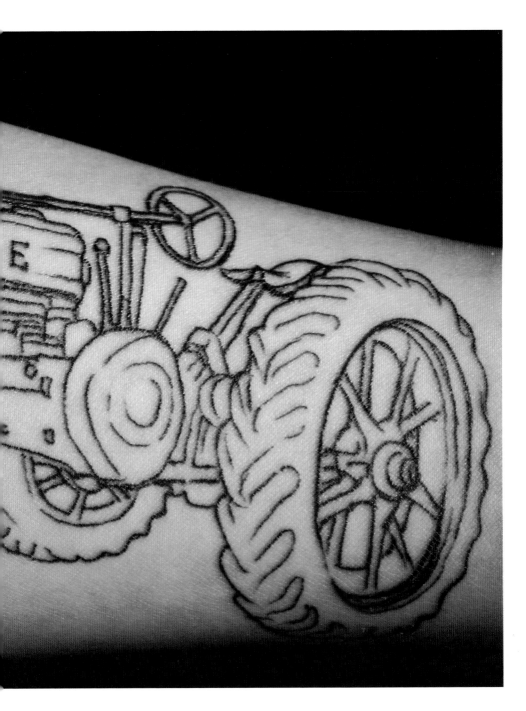

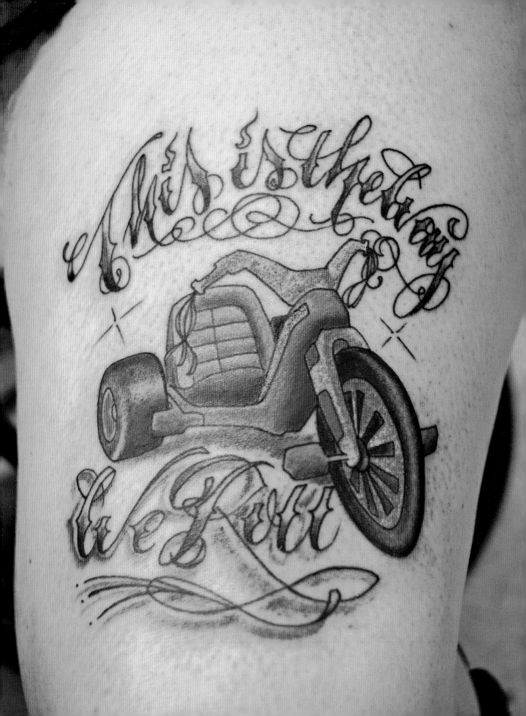

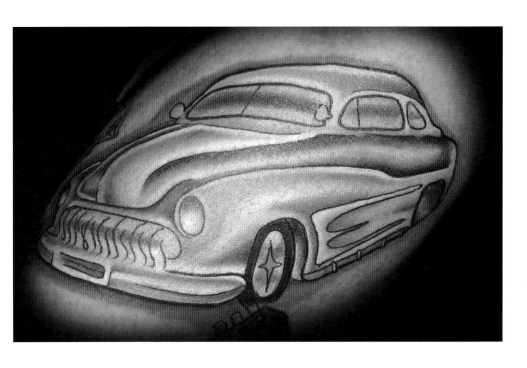

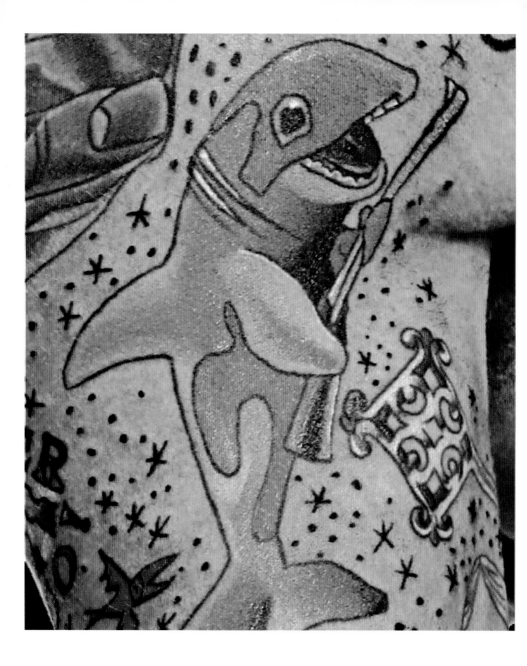

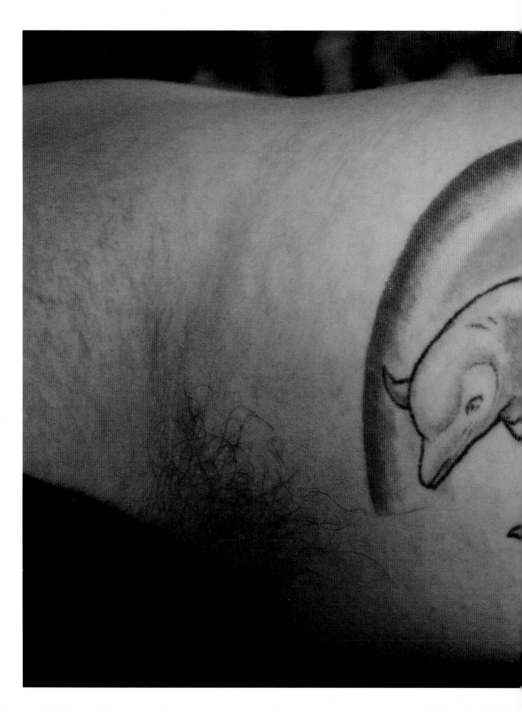

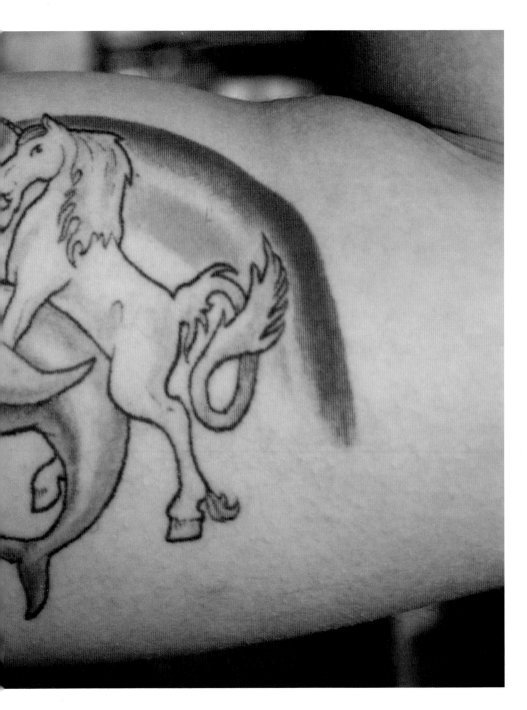

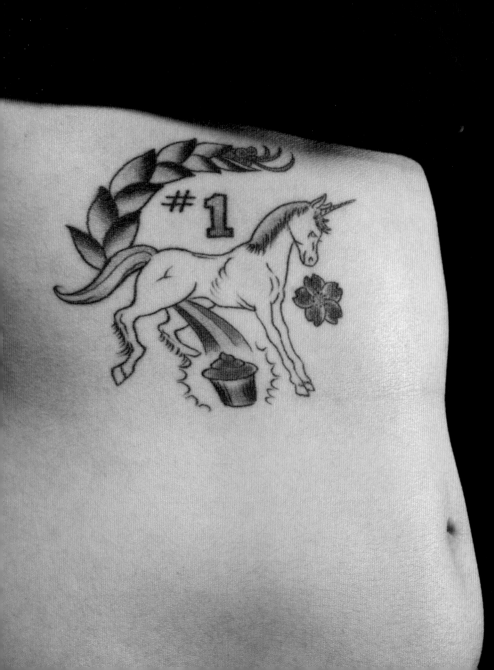

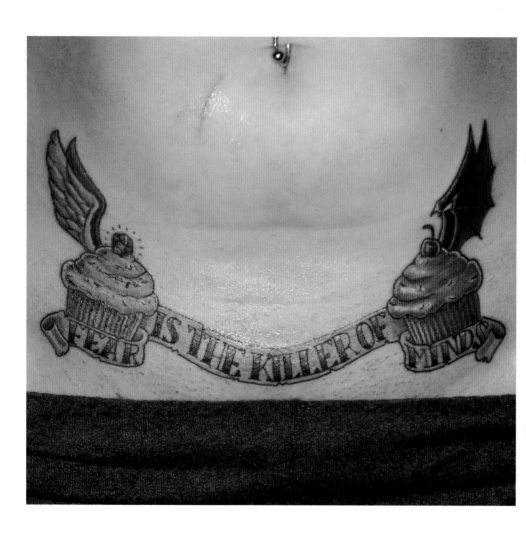

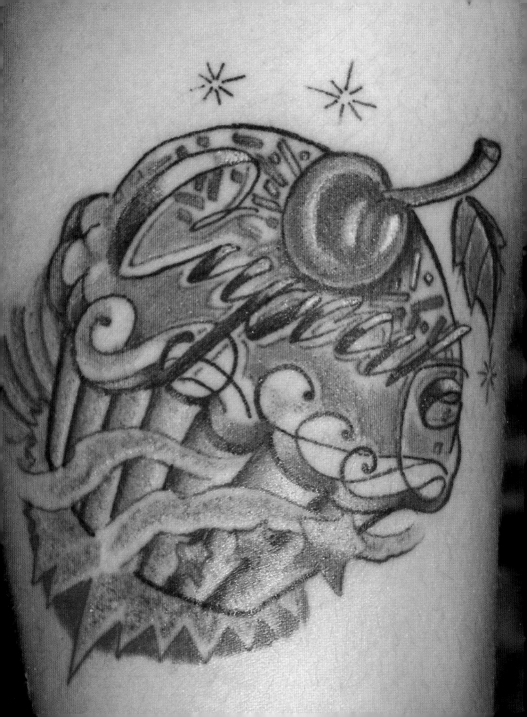

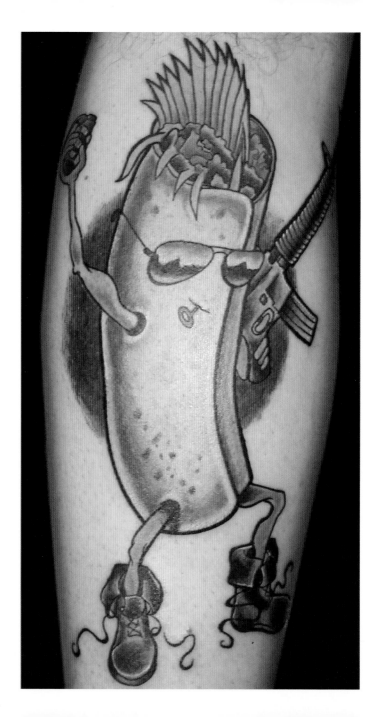

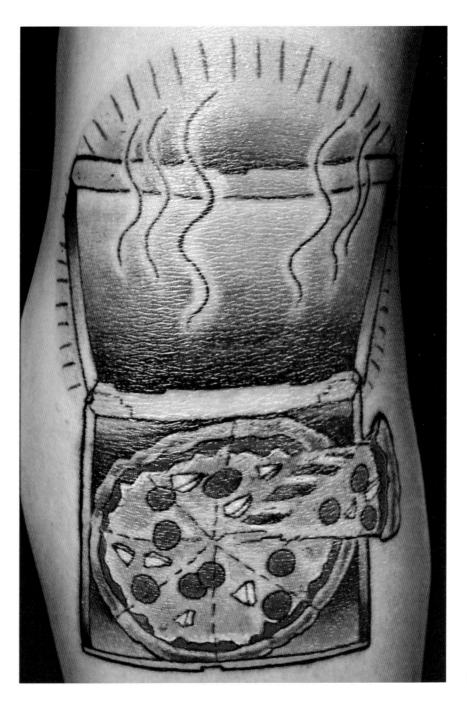

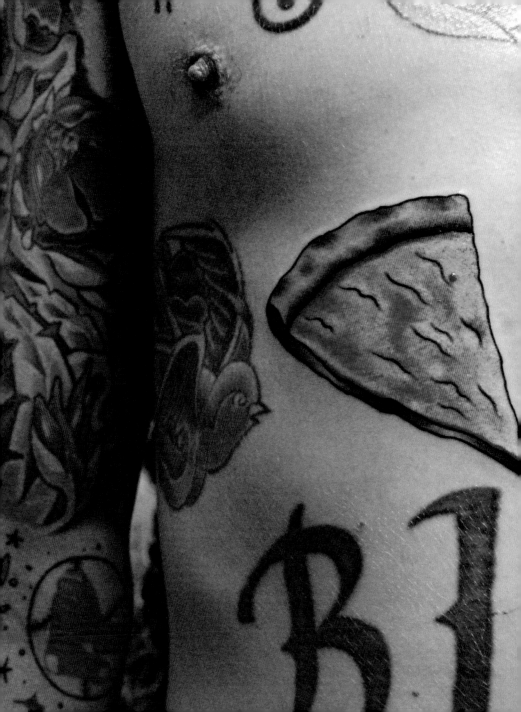

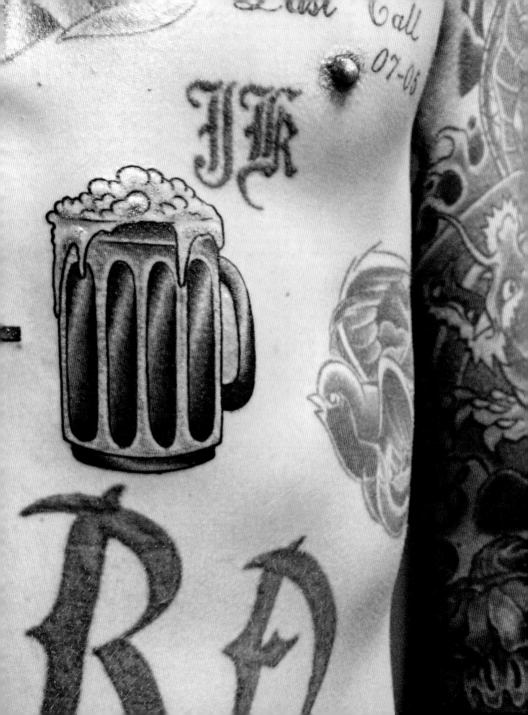

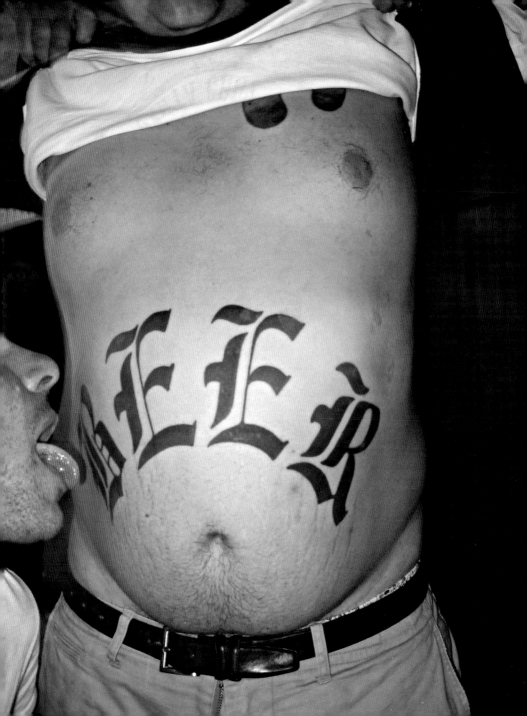

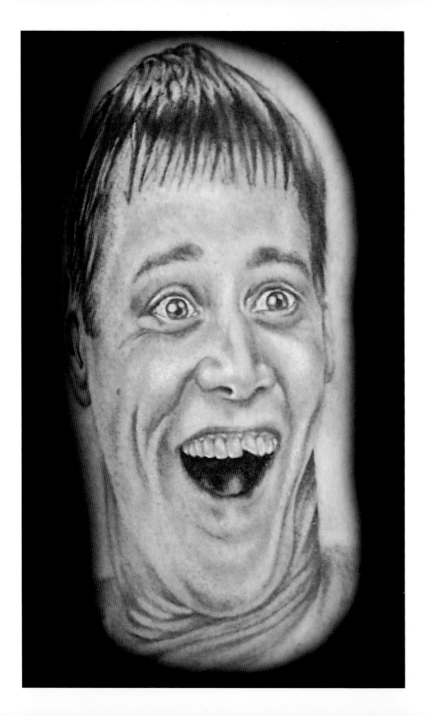

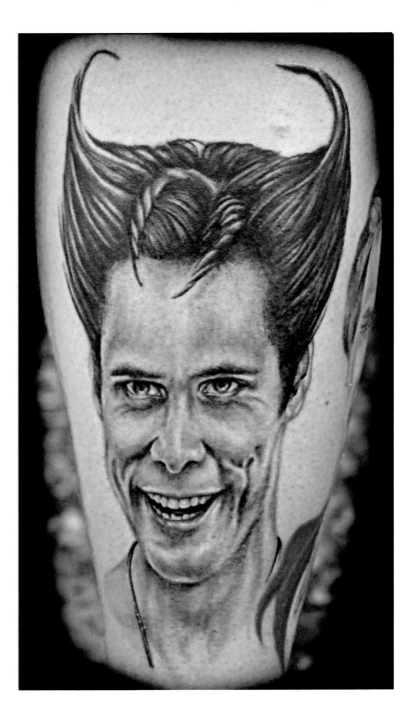

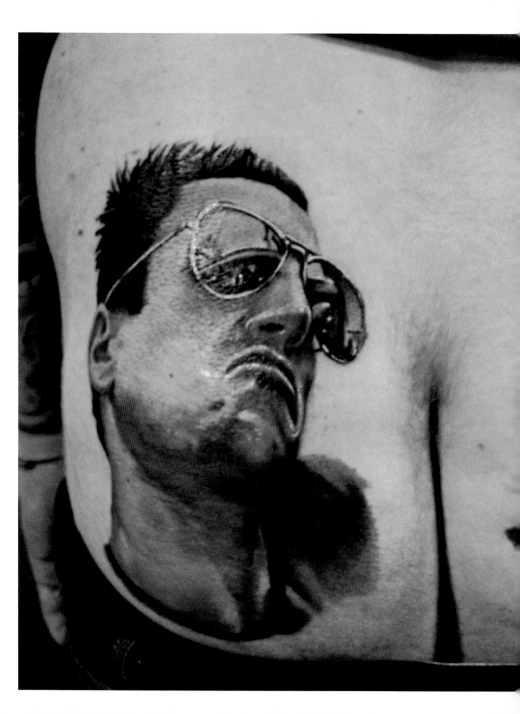

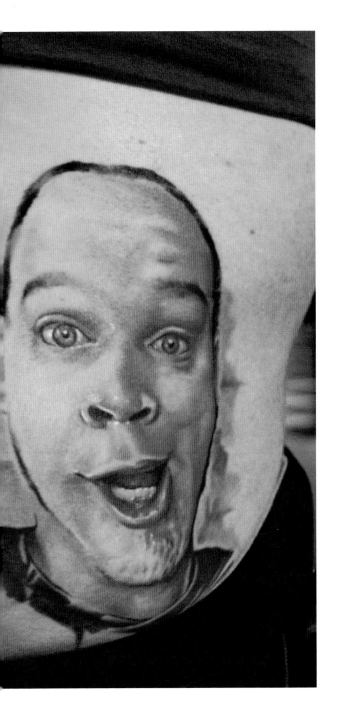

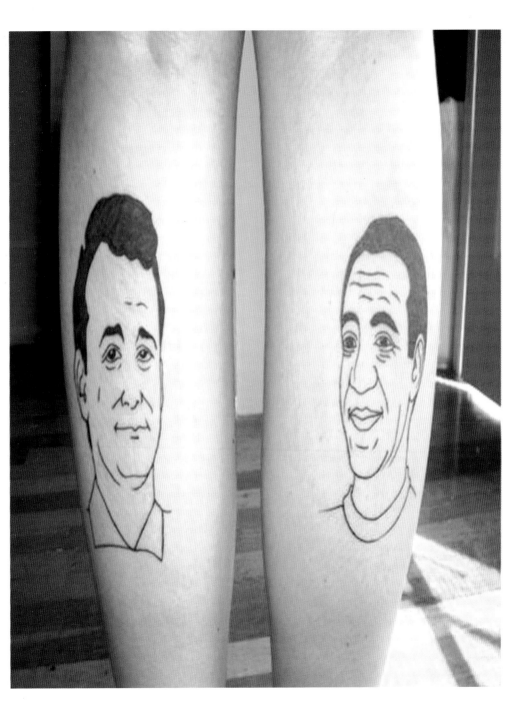

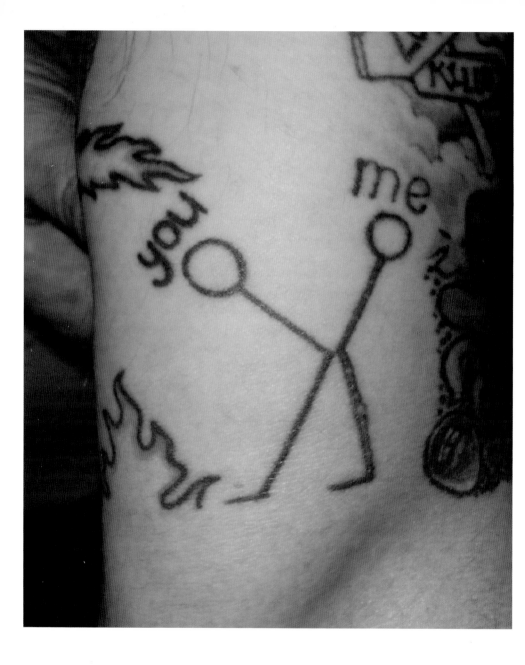

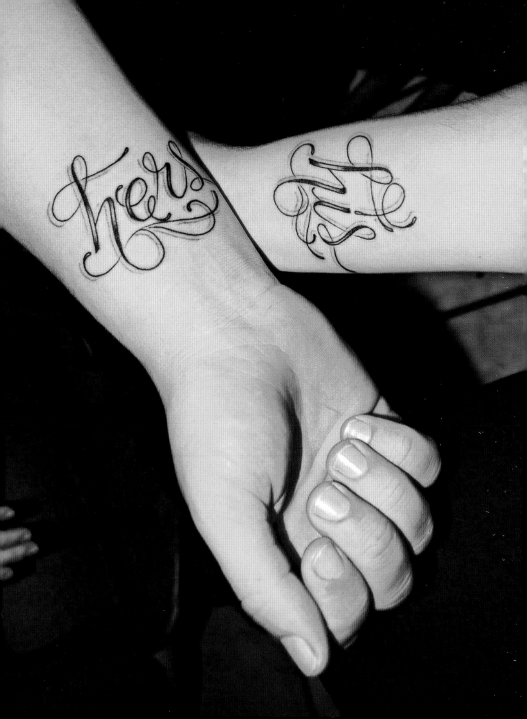

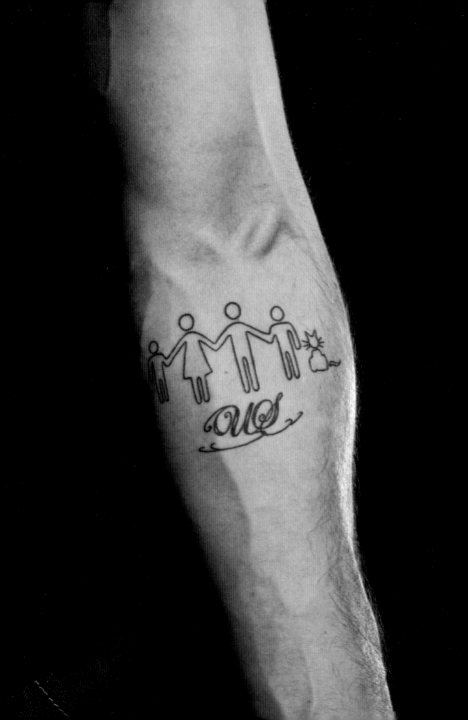

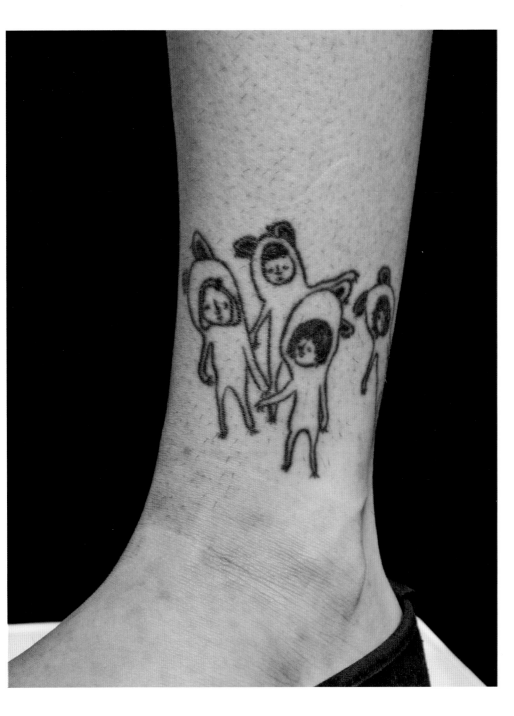

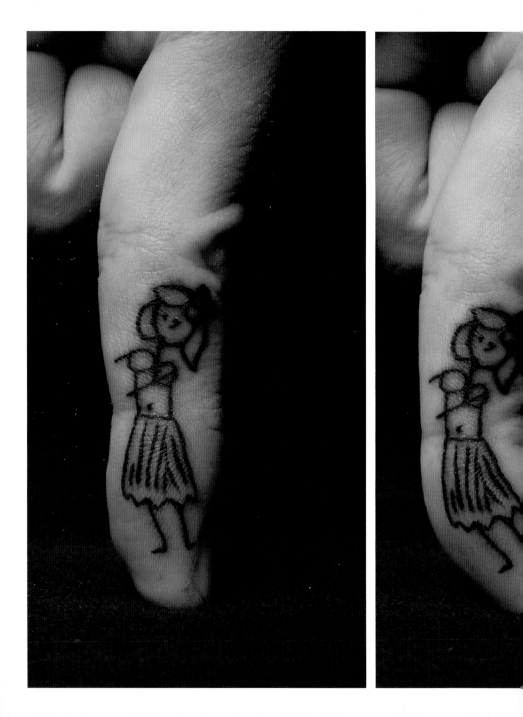

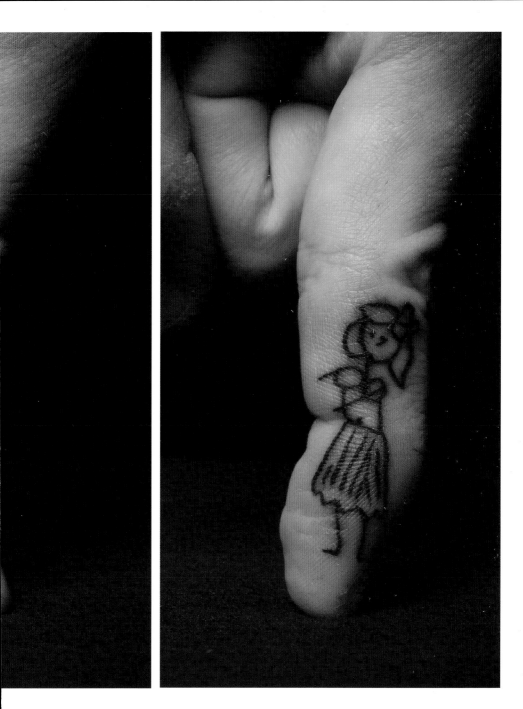

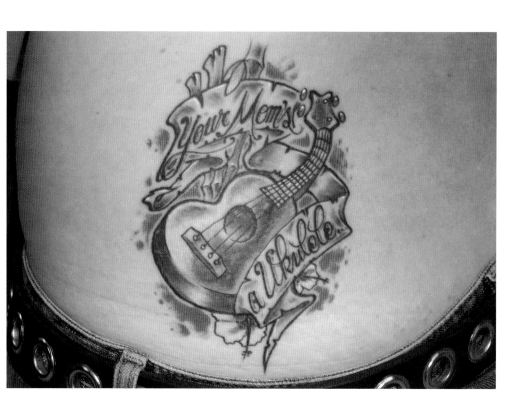

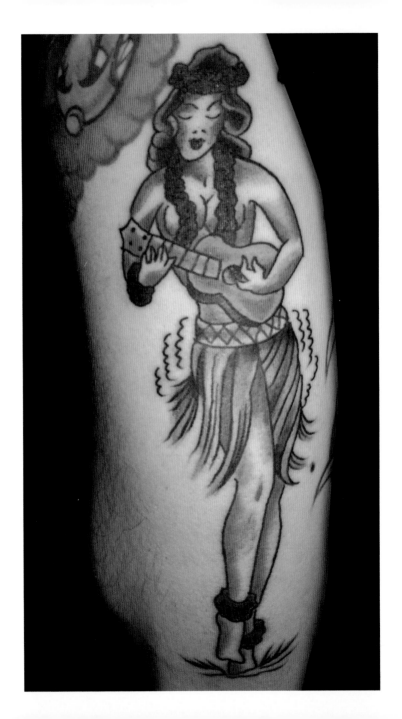

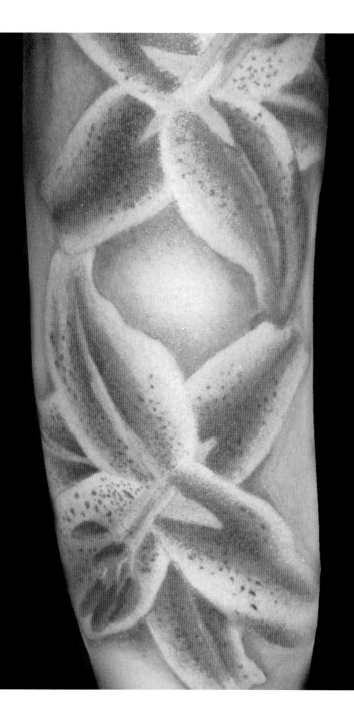

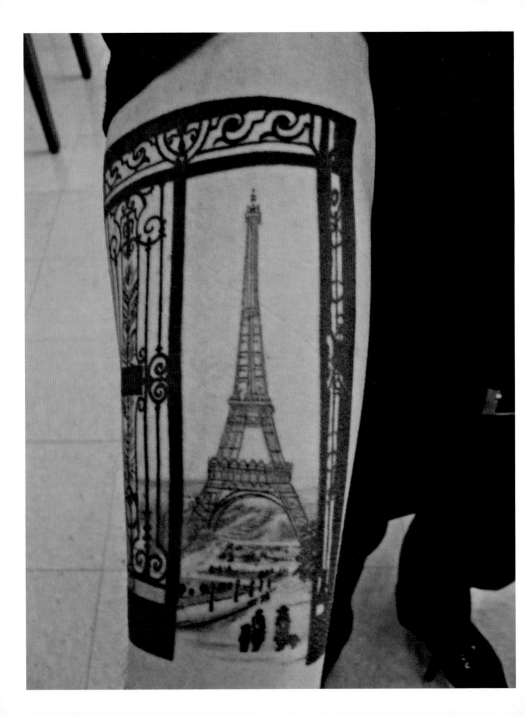

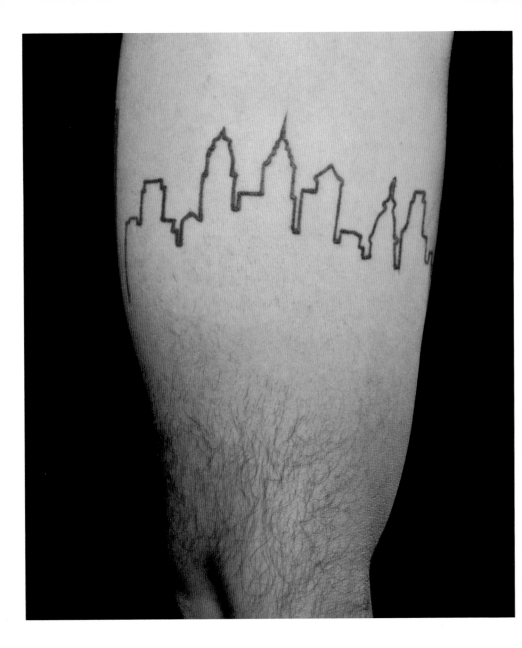

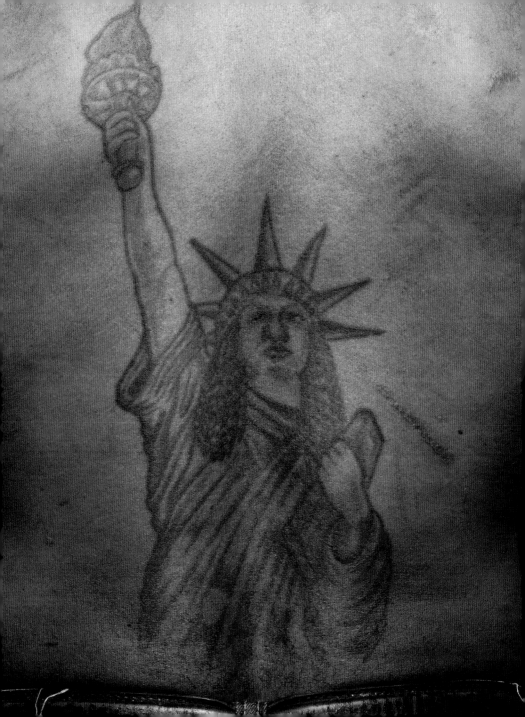

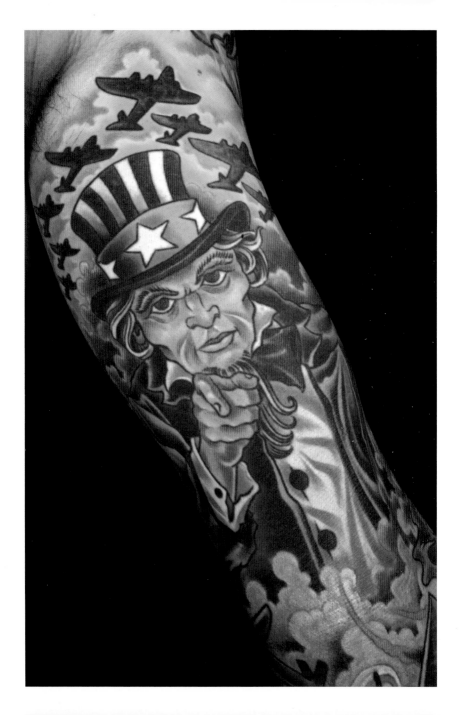

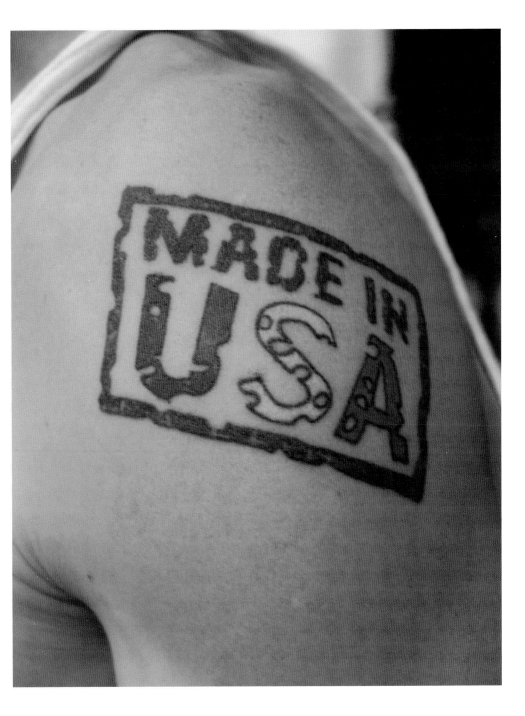

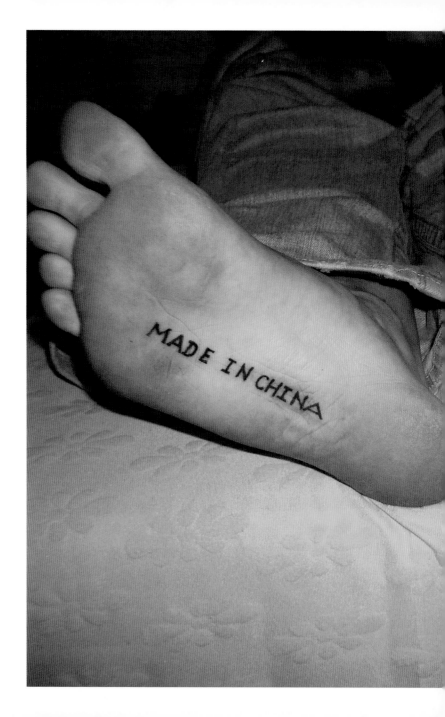

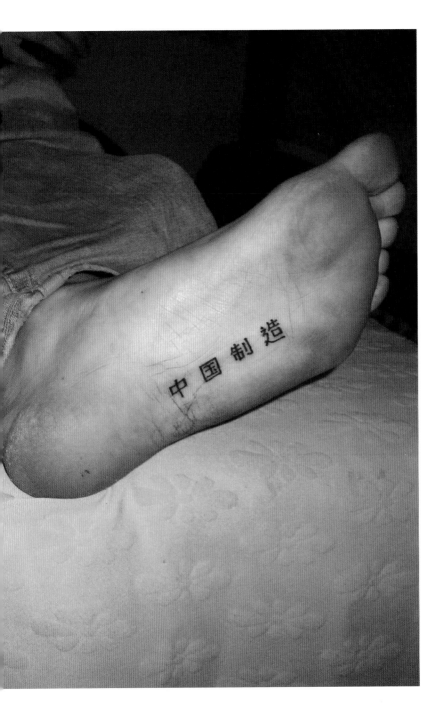

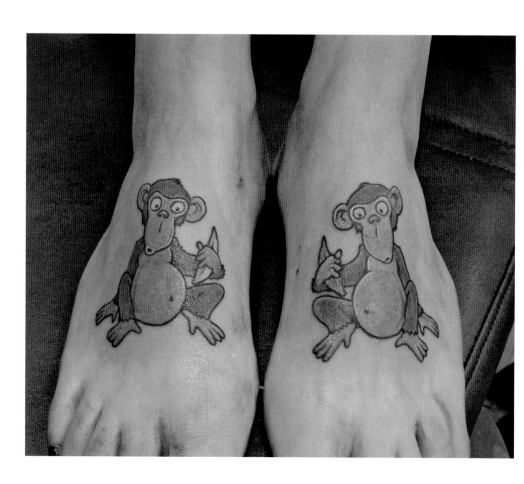

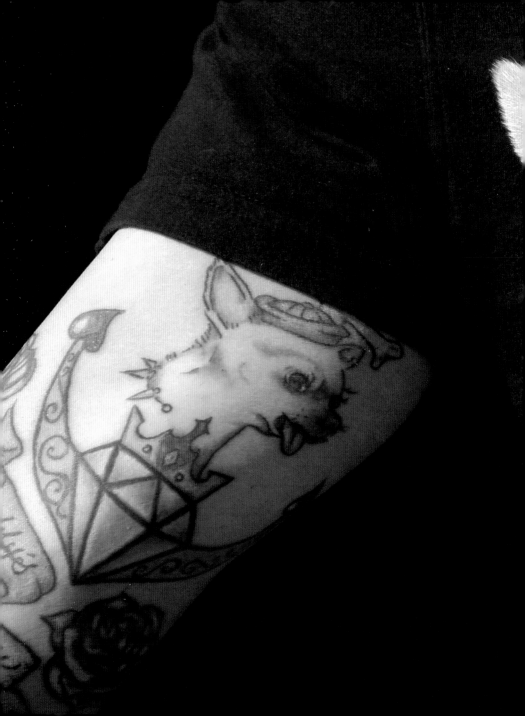

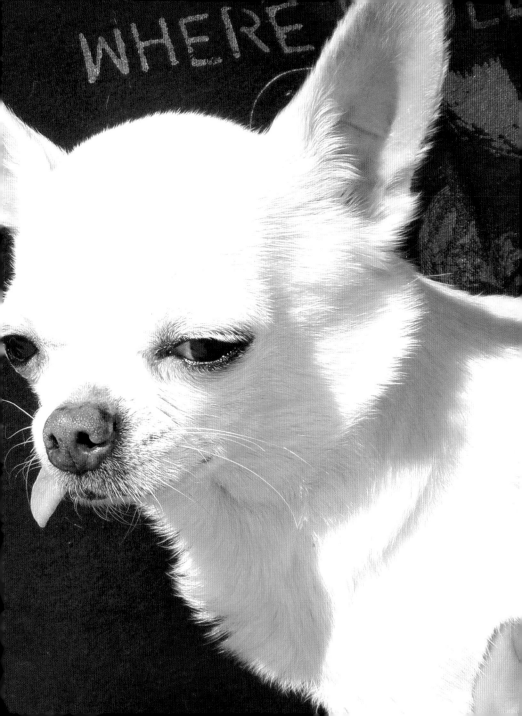

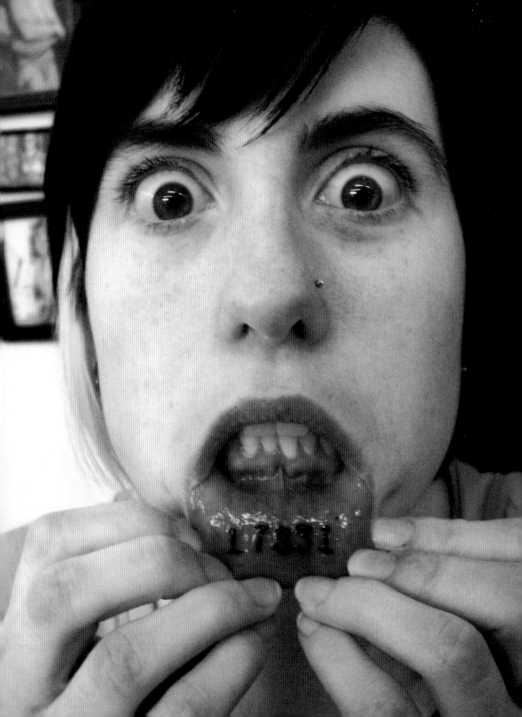

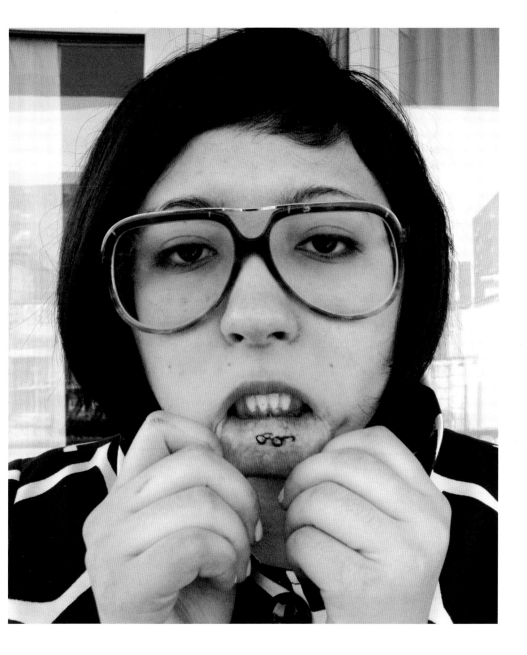

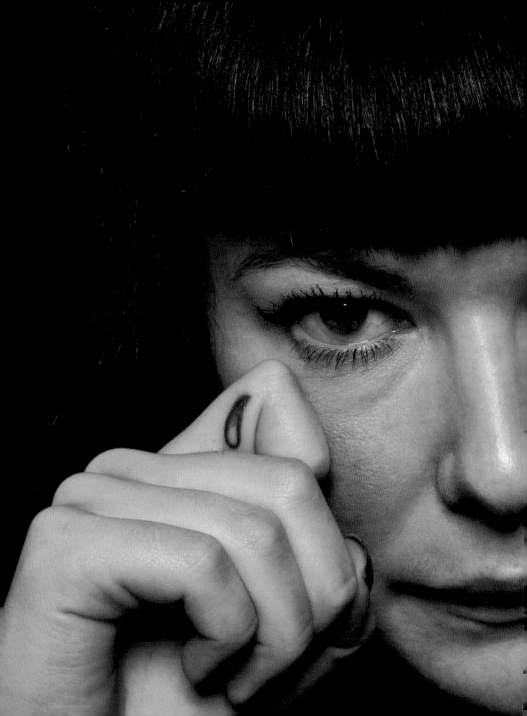

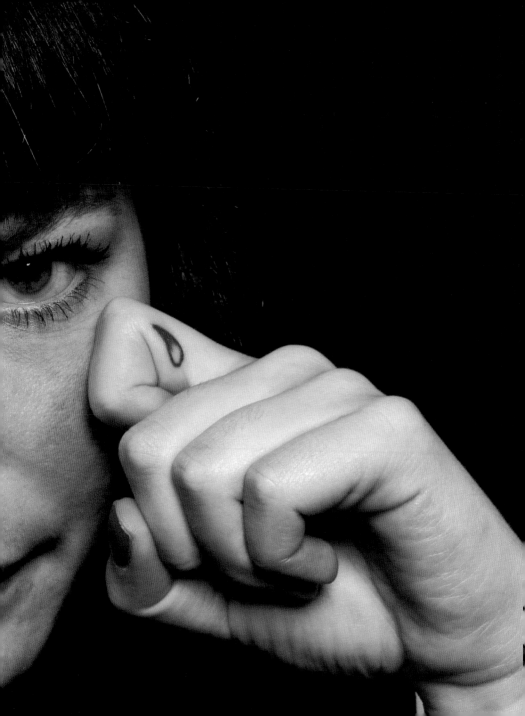

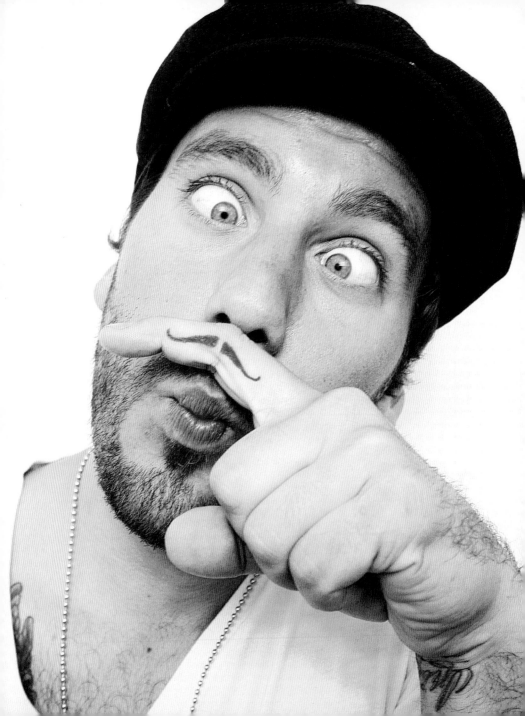

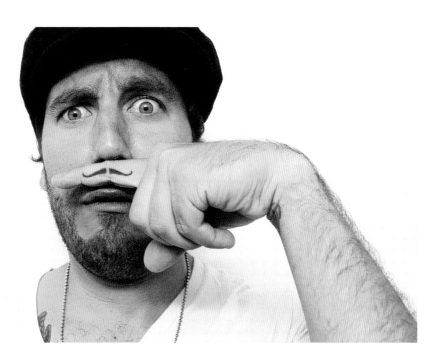

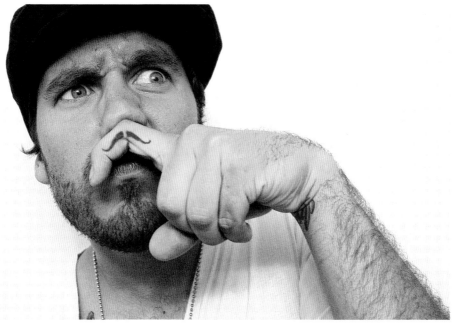

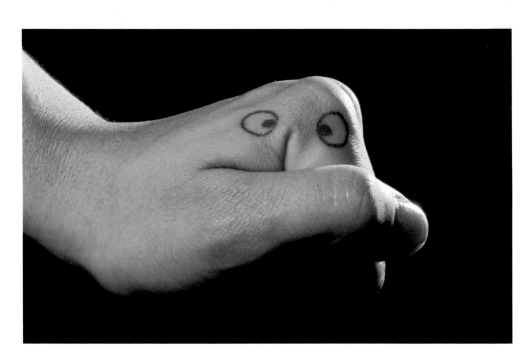
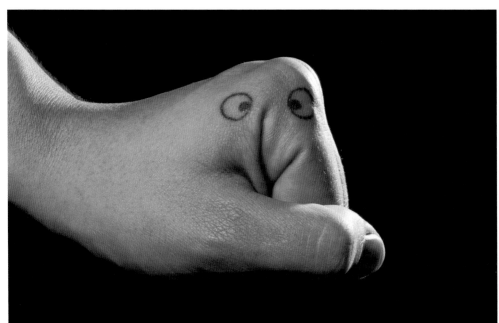

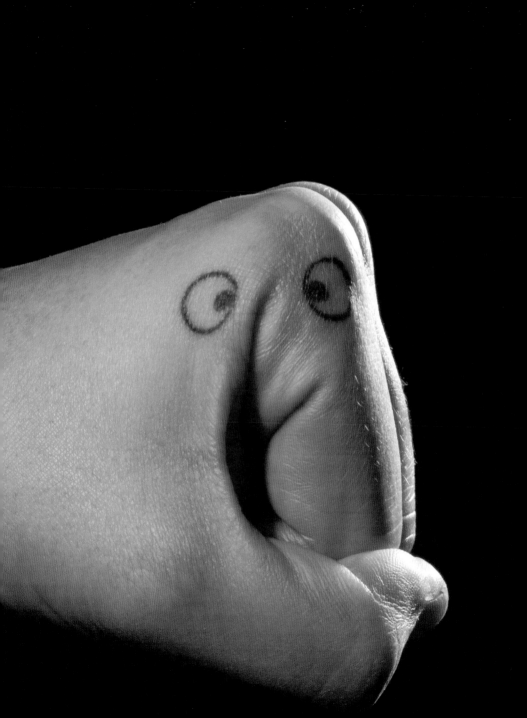

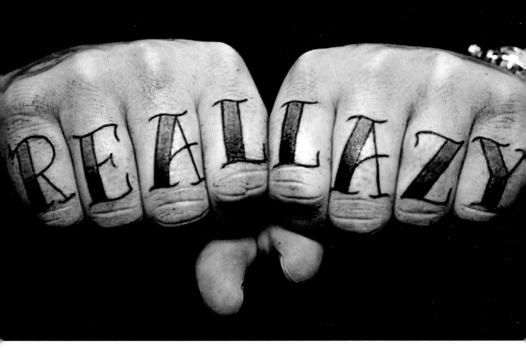

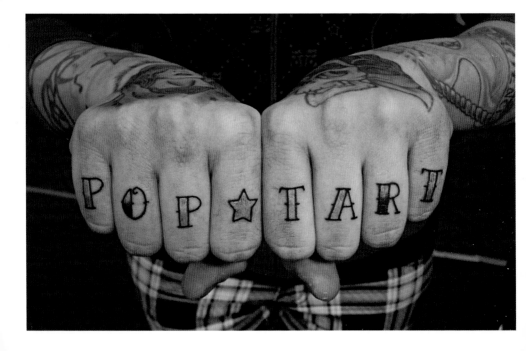

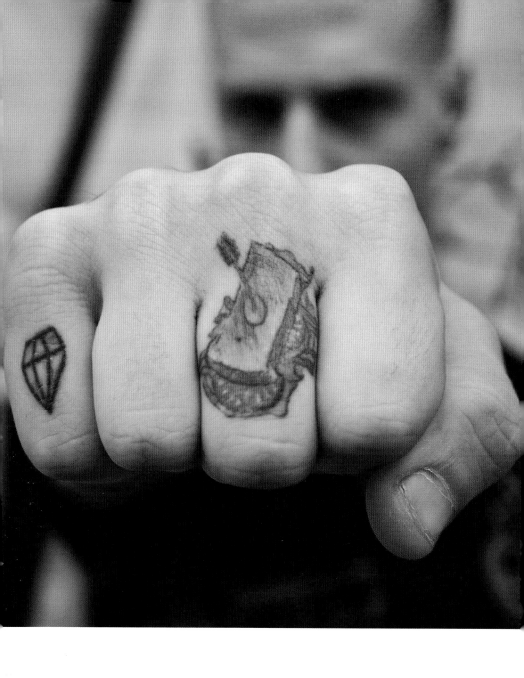

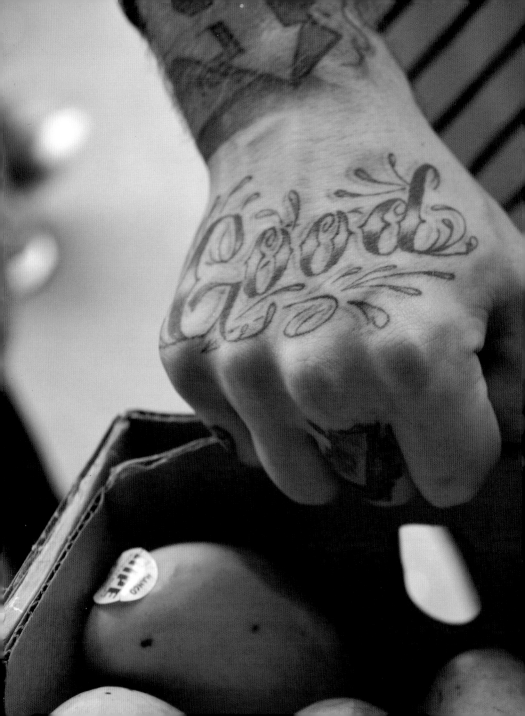

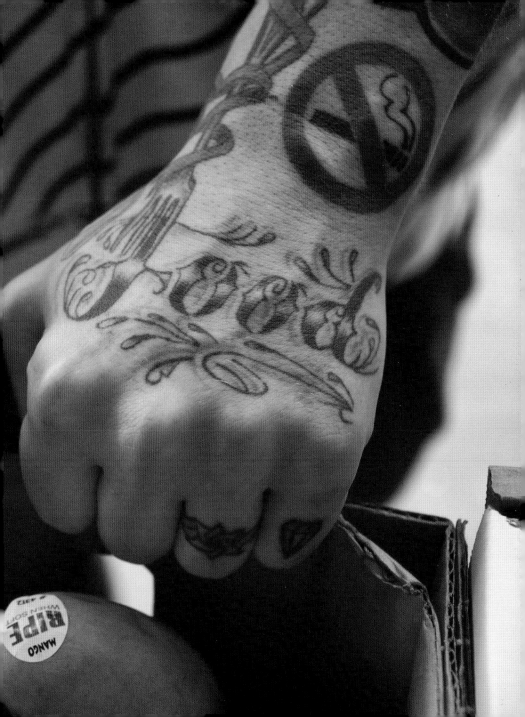

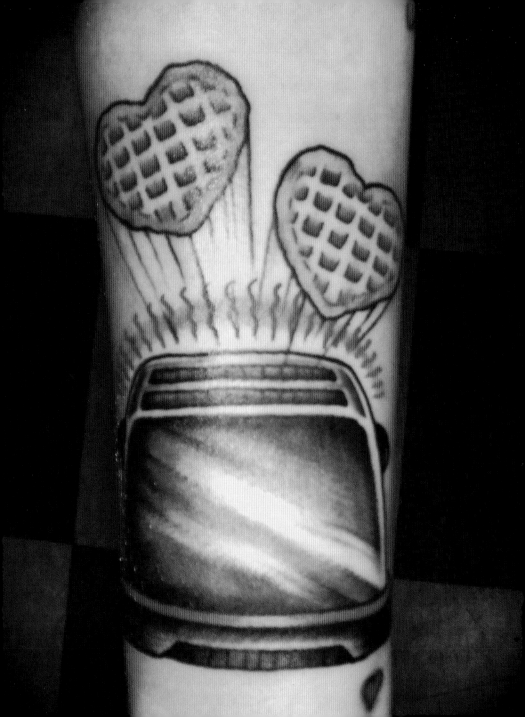

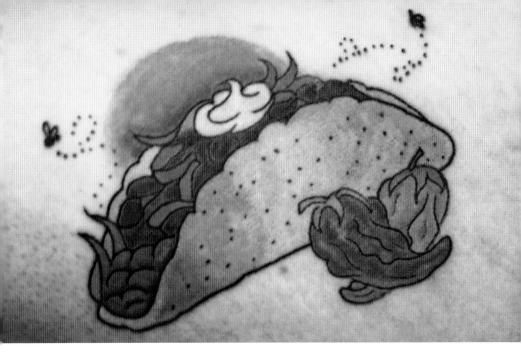

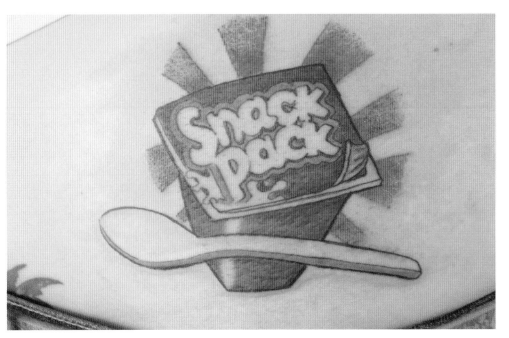

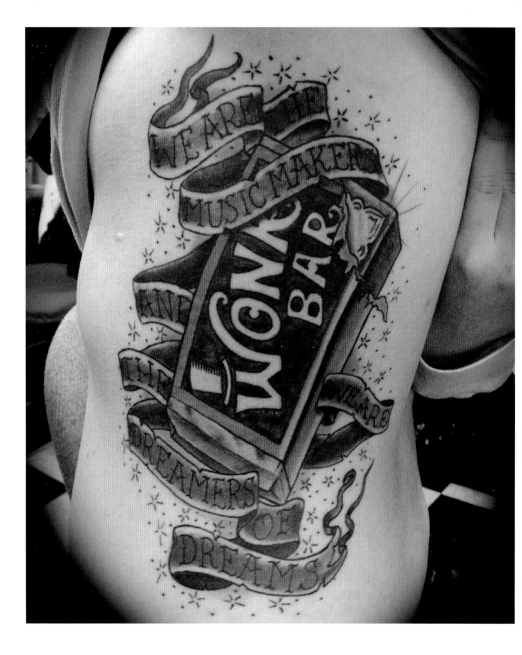

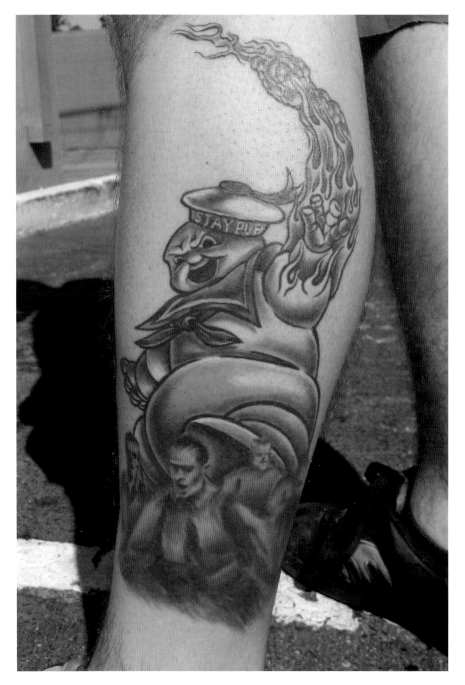

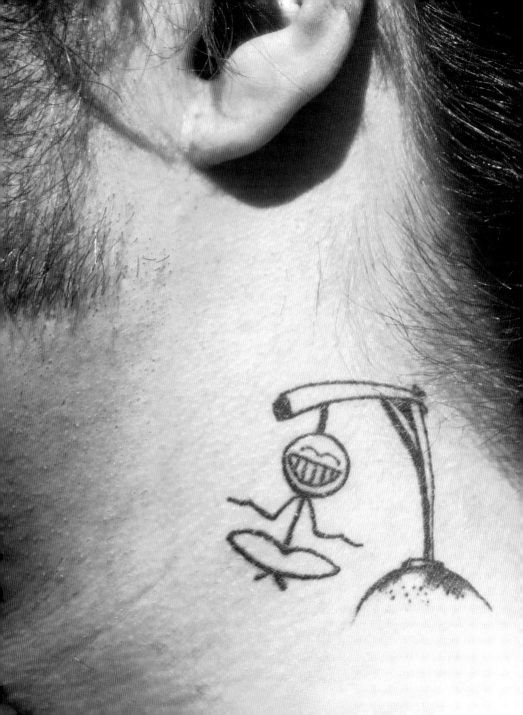

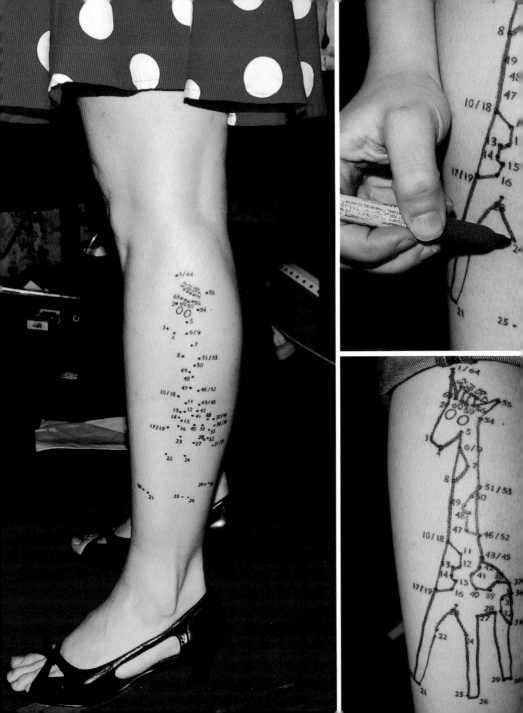

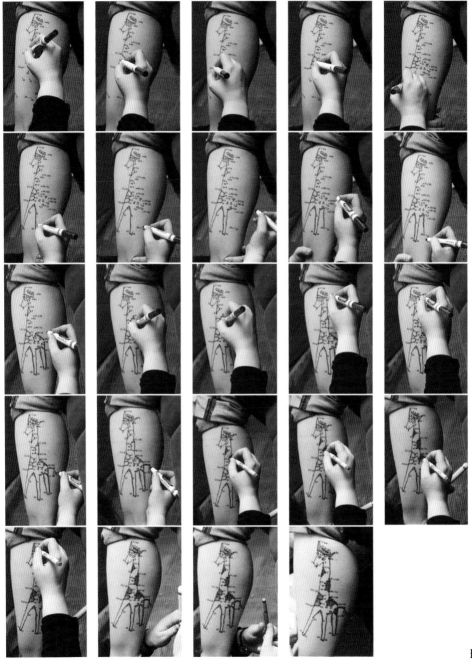

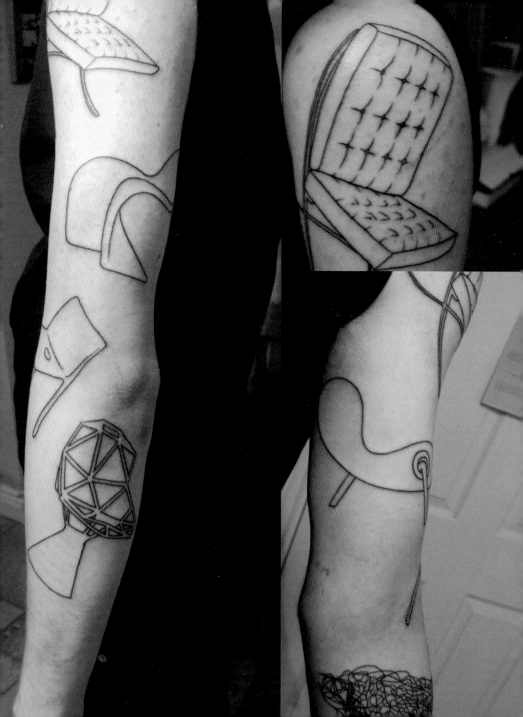

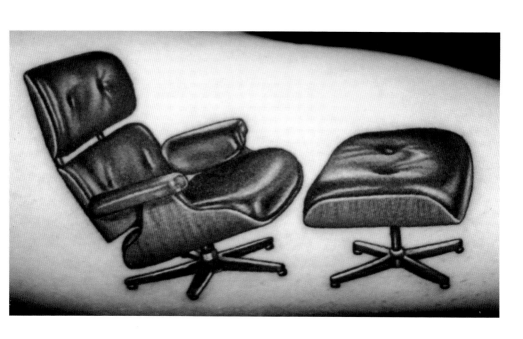

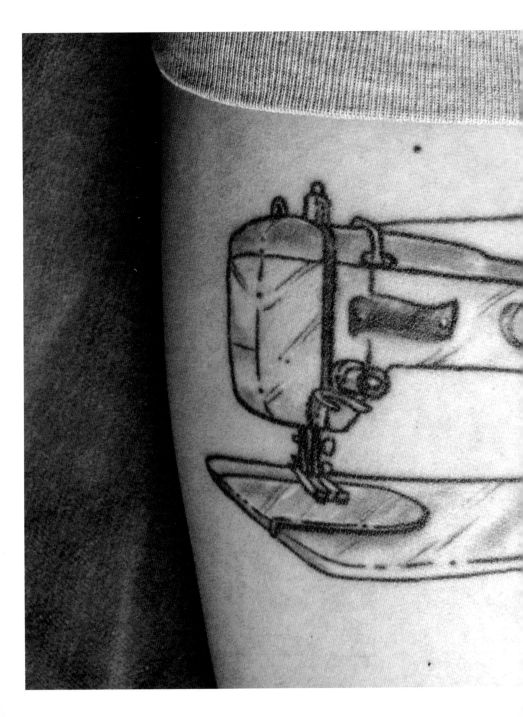

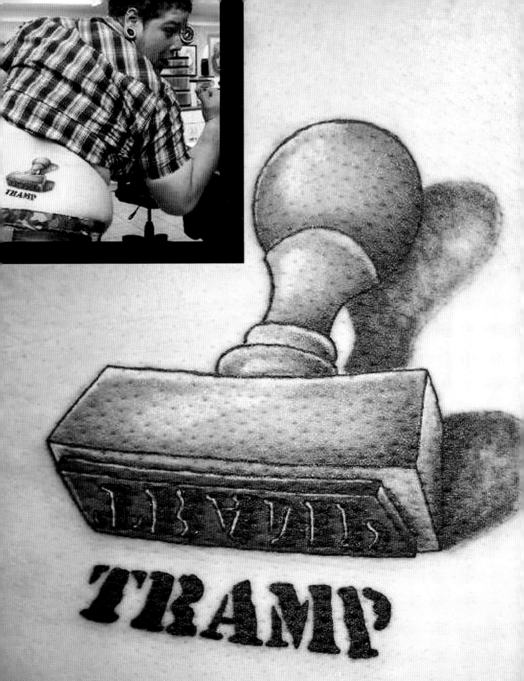

TRAMP

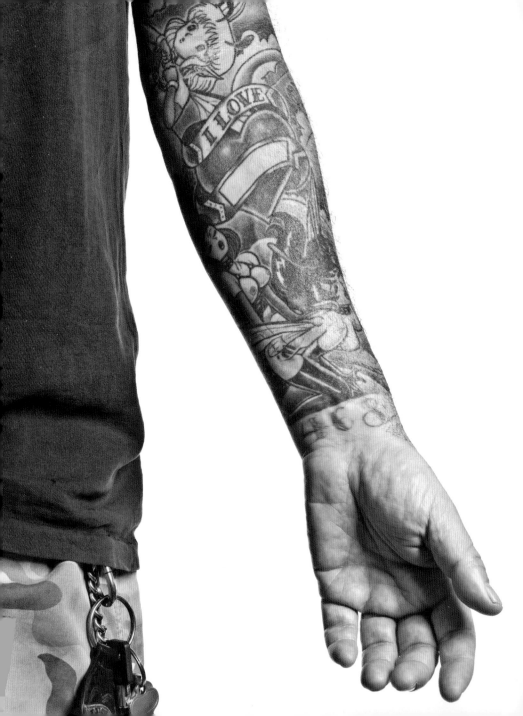

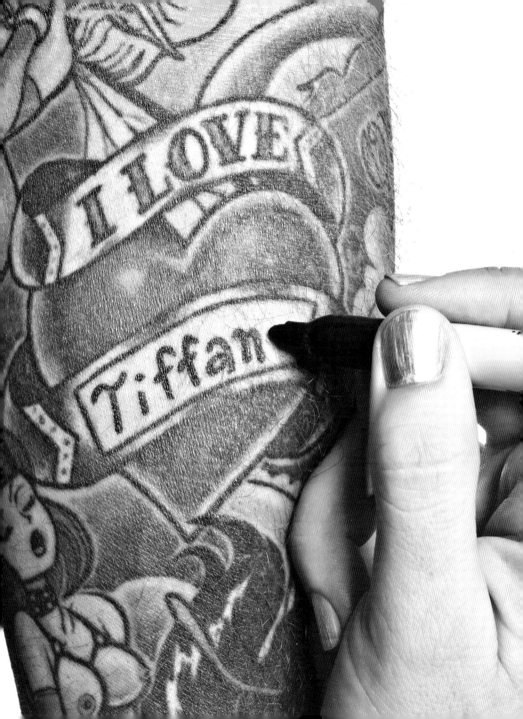

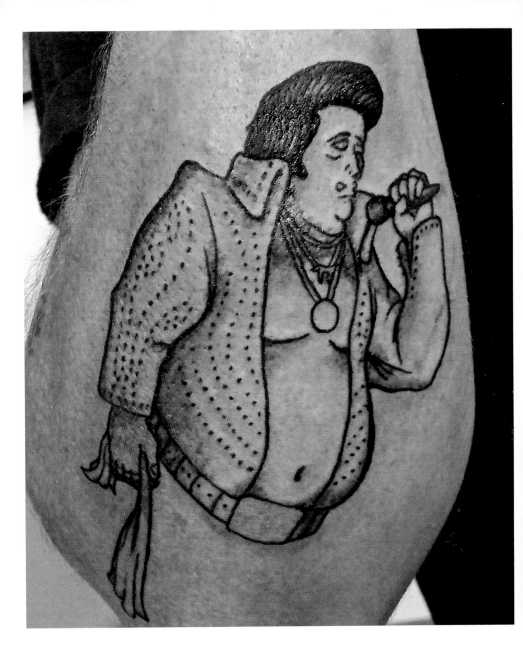

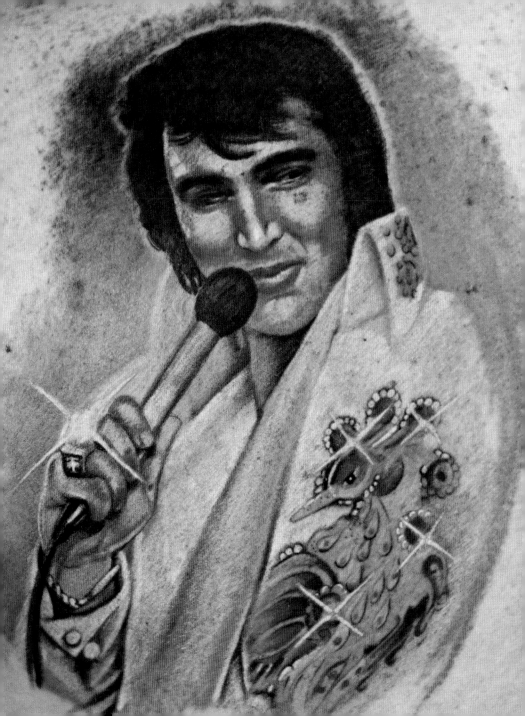

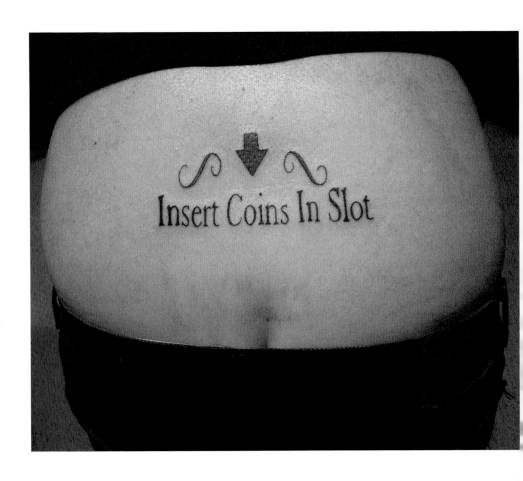

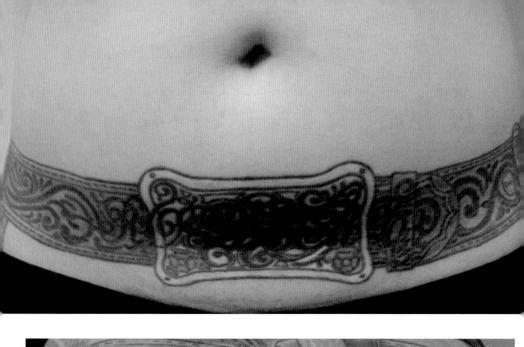

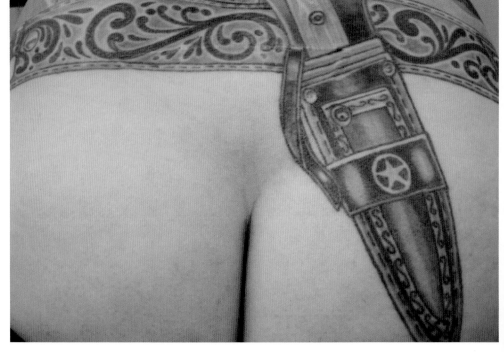

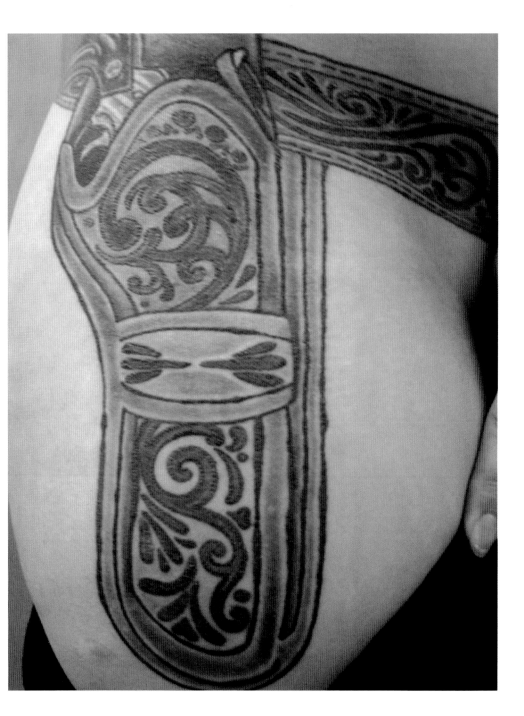

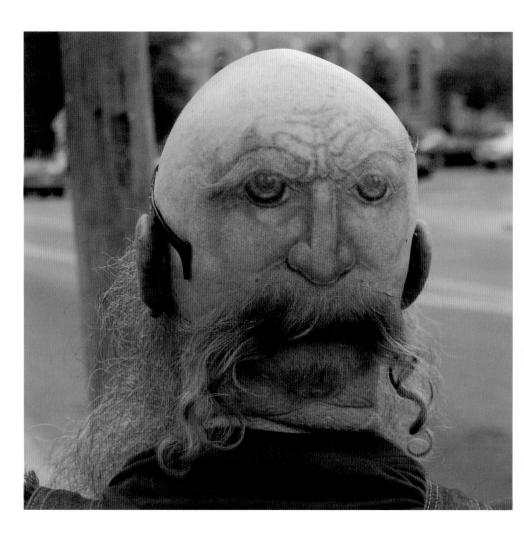

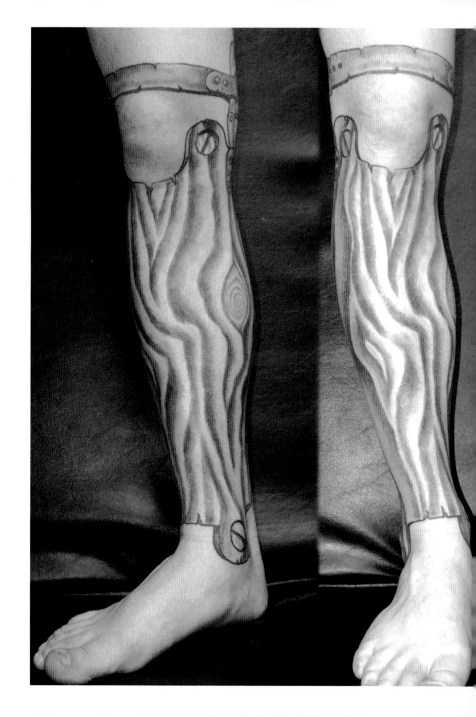

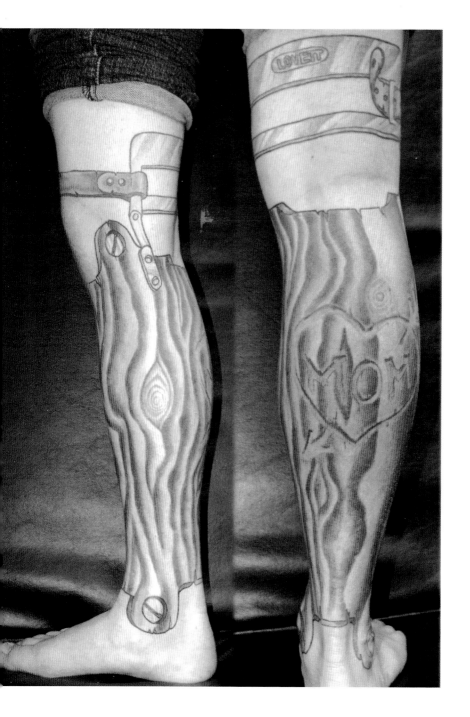

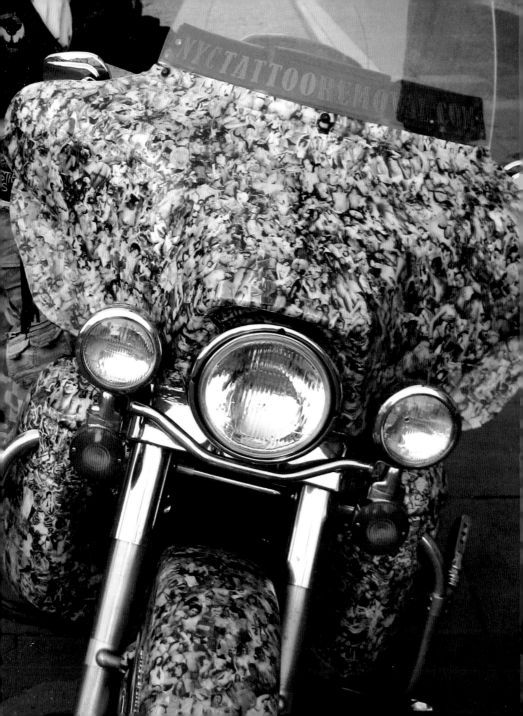

THANK YOU

We'd like to give special thanks to all whose cooperation and kindness assisted us in our image search: Dave C. Wallin from Tattoo Culture, Brooklyn, NYC; Gabe Ripley from Off the Map Tattoos, Easthampton, MA; "T" Massari from Electric Soul Tattoo, Lancaster, CA; Adam Lauricella from Graceland Tattoos, Wappingers Falls, NY; Dan Willems; Gabby Moore; Missi Blue; Bastian Elksnat; and Greg Irikura. And thank you to all who submitted images even if not selected for the book.

p. 9: *A Bright Idea* (on head)
Jayson Deliberto (model)
Jesse Estrada (tattoo artist),
Electric Soul Tattoo,
Lancaster, CA

pp. 10–11: Notepad
(on inner wrist)
Erik Thomas Burke
(model/photographer)

pp. 12–13: An electrician's ruler,
literally (on arm)
Michael Sklar (model)
Wendy Tremayne (photographer)

p. 14 (top): Copyright (on foot)
Sarah Simpkin (model)

p. 14 (bottom): Apostrophe
(on wrist)
Ellie Ubinas (model)

p. 15: Remington typewriter
(on leg)
Anne Burge (model)
Ian Meyer (photographer)

p. 17: *Deep Thoughts* (on head)
Jonathan Chevlin (model)
Jeff Kozan (tattoo artist),
Vatican Tattoo,
Ft. Lauderdale, FL
Greg Irikura (photographer)

pp. 18–19: Third nipple (on torso)
Jonathan Chevlin (model)
Greg Irikura (photographer)

p. 20: Ham (on nipple)
Michael J. Bradbury (model)
Jenni Snead (photographer)

p. 21: *Side of Bacon* (on torso)
Liza Danger, Seattle, WA
(model)

p. 22: Hot dog in a coffin
(on arm)
Mark Murrmann (model),
www.ickibod.com/action

p. 25: Holy toaster (on arm)
Matt Goldpaugh (model)

p. 26 (top): Holy moly (on fists)
Jayson Deliberto (model)
Jason Porter (tattoo artist),
Naked Art Tattoos,
Odenton, MD

p. 26 (bottom): Blessed
Chihuahua (on hand)
Jayson Deliberto (model)
Chris Lowe (tattoo artist),
Naked Art Tattoos,
Odenton, MD

p. 27: Untitled
Brian Murphy (tattoo artist),
Third Dimension Tattoos,
East Stroudsburg, PA
www.thirddimensiontattoos.com

p. 28: Jesus and Buddha
(on arm)
May Yu (model)
Adam Hays (tattoo artist),
Red Rocket Tattoo,
New York, NY

p. 29: Buddy Jesus bobble–head
Amy Wagner (tattoo artist),
Tattoo Licious, Honolulu, HI

p. 30: Pull my finger (on arm)
Cole Fraley (model)

p. 33: Xavier Roberts signature
from a Cabbage Patch doll
(on butt)
Kate Clagg (model)
Gabriel "Gabby" Moore
(tattoo artist),
Marked 4 Life, York, PA

p. 34: Sloth from the movie,
The Goonies (on leg)
Katy Sobieck (model)
Cory Norris (tattoo artist)
Classic Tattoo, Grass Valley, CA
www.corynorristattoo.com

p. 35: Mr. Miyagi from the movie,
The Karate Kid (on arm)
Jay Worley (model)
Kyle Cotterman (tattoo artist),
Ink Revolution Studios,
Kingsport, TN

pp. 36–37: Music note with a
tear, UV blacklight tattoo
(on arm)
Pierre de Gaillande (model)
Greg Irikura (photographer)

p. 38–39: E.T. phone home
from the movie, *E.T.:
The Extra-Terrestrial* (on leg)
Adam Brooks (model)
Billy Toler (tattoo artist),
Cherry Bomb Tattoos,
New Port Richey, FL

p. 40: *Death before Darkside*
Josh Lobiando (model)
Adam Hays (tattoo artist),
Red Rocket Tattoo,
New York, NY

p. 41: *R2, the Ultimate Wingman*
Adam Hays (tattoo artist),
Red Rocket Tattoo,
New York, NY

pp. 42–43: Light sabre
(on shoulders)
Josh Lobiando (model)
Adam Hays (tattoo artist),
Red Rocket Tattoo,
New York, NY

p. 44: Yoda from the movie, *Star Wars* (on shoulder)
Evan Campbell (tattoo artist), Electric Soul Tattoo, Lancaster, CA

p. 45: Darth Vader from the movie, *Star Wars* (on leg)
Caleb Martin IV (model)
Tom Hayden (tattoo artist), Mental Mayhem Tattoos, Scranton, PA
Rina Madarang (photographer)

p. 47: Untitled (on neck)
Brian Murphy (tattoo artist), Third Dimension Tattoos, East Stroudsburg, PA
www.thirddimensiontattoos.com

pp. 48–49: Biplane (on arm)
Jeremy James (model/photographer)

pp. 50–51: Tractor (on arm)
Anne Burge (model)
Ian Meyer (photographer)

p. 52: *This is the Way We Roll* (on leg)
Jennifer Lynne (model)
David Zobel (tattoo artist), Brookland Park Tattoo, Richmond, VA

p. 53: Car
Alexandria Massari (tattoo artist), Electric Soul Tattoos, Lancaster, CA

p. 54: *Killer Whale* (on shoulder)
Amy Wagner (tattoo artist), Tattoo Licious, Honolulu, HI

pp. 56–57: *Unicorn* (on arm)
Jake Szufnarowski (model)
Glenn Hidalgo (designer)
Bruce Gulick (tattoo artist), www.brucegulick.com

p. 58: Unicorn (on torso)
Marilyn Pondón (model)
Mark Harada (tattoo artist), East Side Ink, New York, NY
Greg Irikura (photographer)

p. 60: *Fear is the Killer of Minds* (on stomach)
Tad Coleman (tattoo artist), Vertigo Tattoo, Manns Harbor, NC

p. 61: Cupcake (on arm)
Jennifer Lynne (model)
David Zobel (tattoo artist), Brookland Park Tattoo, Richmond, VA

p. 62: Dancing burrito
Amy Wagner (tattoo artist), Tattoo Licious, Honolulu, HI

p. 63: Pizza
Amy Wagner (tattoo artist), Tattoo Licious, Honolulu, HI

pp. 64–65: Pizza + Beer (on stomach)
Erick Lynch (tattoo artist), Redemption Tattoo, Cambridge, MA
www.redemptiontattoo.com

p. 67: *Beer Belly* (on stomach)
L. Anderson (photographer)

p. 68: Lloyd Christmas from the movie, *Dumb and Dumber*
Nick Testa (model)
Billy Toler (tattoo artist), Cherry Bomb Tattoos, New Port Richey, FL

p. 69: Ace Ventura from the movie, *Ace Ventura* (on leg)
Benjamin Henderson (model)
Billy Toler (tattoo artist), Cherry Bomb Tattoos, New Port Richey, FL

pp. 70–71: *Friends* (on butt cheeks)
Clay Powers (model)
Cory Norris (tattoo artist), Classic Tattoo, Grass Valley, CA
www.corynorristattoo.com

p. 73: *Two Bills* (on legs)
Jessica Thompson (model)
Kele Idol (tattoo artist), Aerochild Tattoos, Birmingham, AL

p. 74: *You and Me* (on leg)
Cole Fraley (model)

p. 75: *Hers & His* (on inner wrists)
Joey and Liza, Seattle, WA (models)

p. 76: *Us* (on arm)
Mark Peddigrew (model)
João–Paolo (tattoo artist), Rising Dragon Tattoos, New York, NY
Greg Irikura (photographer)

p. 77: Little people (on ankle)
Marilyn Pondón (model)
Greg Irikura (photographer)

pp. 78–79: Hula girl (on finger)
Brian Brown (model)
Greg Irikura (photographer)

p. 81: *Your Mom's a Ukulele*
Tiffany Replogle (model)
Dan Rhodes (tattoo artist),
Tattoo Licious, Honolulu, HI

p. 82: Hula girl
Amy Wagner (tattoo artist),
Tattoo Licious, Honolulu, HI

p. 83: Tiger lilies (on arm)
Alexandria Massari
(tattoo artist),
Electric Soul Tattoos,
Lancaster, CA

p. 84: Eiffel Tower (on arm)
Andrew Ross Ortner (model)
Joseph Ari Alloi (tattoo artist),
Saved Tattoo, Brooklyn, NY

p. 86: Philadelphia skyline
(on arm)
Mark Buettler (model)
Greg Irikura (photographer)

p. 87: Statue of Liberty (on back)
Mino Jones (model)
Greg Irikura (photographer)

p. 88: Uncle Sam (on arm)
Durb Morrison (tattoo artist),
Hell City Tattoo,
www.durbster.com

p. 89: Made in the USA (on arm)
Bill Taylor (model)
Rina Madarang (photographer)

pp. 90–91: Made in China
(on foot)
Katie Irwin (model)

p. 92: *Guarded by Monkeys*
(on feet)
Vix Kelley (model)
Gabriel "Gabby" Moore
(tattoo artist),
Marked 4 Life, York, PA

pp. 94–95: *Portrait of Flea*
(on arm)
Flea (chihuahua)
Frank Allen
(tattoo model/tattoo artist),
Madison Tattoo Shoppe,
Toluca Woods, CA
Marissa Diaz (photographer)

p. 96: *Hanover, PA 17331*
(inner lip)
Alison MacAvoy (model)
Gabriel "Gabby" Moore
(tattoo artist)
Marked 4 Life, York, PA

p. 97: Glasses (inner lip)
Karen J. Sawicki (model)

pp. 98–99: Tears (on fingers)
Daniela Duff (model)
Greg Irikura (photographer)

pp. 100–101: Finger mustache
(on finger)
Sr. Morgan Perez-Rubio (model)
Shawn Fender (photographer)

pp. 102–103: Eyes (on hand)
Anna Maltezos (model)
Greg Irikura (photographer)

p. 104 (top): *Real Lazy*
(on knuckles)
Durb Morrison (tattoo artist)
Hell City Tattoo,
www.durbster.com

p. 104 (bottom): *Pop Tart*
(on knuckles)
Vix Kelley (model)
Gabriel "Gabby" Moore
(tattoo artist),
Marked 4 Life, York, PA

p. 105: *Knuckle Sandwich*
(on knuckle)
Jonathan Chevlin (model)
Greg Irikura (photographer)

pp. 106–107: *Good Food*
(on hands)
Jonathan Chevlin (model)
Jeff Kozan (tattoo artist),
Vatican Tattoo Studio,
Ft. Lauderdale, FL
Greg Irikura (photographer)

p. 108: Toaster and heart waffles
(on arm)
Danielle Benson (model)
Adam Hays (tattoo artist),
Red Rocket Tattoo,
New York, NY

p. 109 (top): Taco with flies
Theodore Hodson IV (model)
Sihf (tattoo artist),
Brookland Park Tattoo,
Richmond, VA

p. 109 (bottom): *Snack Pack*
(on waist)
Jennifer Lynne (model)
David Zobel (tattoo artist),
Brookland Park Tattoo,
Richmond, VA

p. 110: *Wonka Bar* (on torso)
Sarah Lee (model)
Adam Hays (tattoo artist),
Red Rocket Tattoo,
New York, NY

p. 111: Stay Puft
Marshmallow Man (on leg)
Tyson Zoltan Heder (model)
Joby Cummings (tattoo artist),
Art & Soul Tattoo Co.,
Los Angeles, CA

p. 112: Aunt Jemima
Johnny Jackson (tattoo artist),
Texas Body Art, Houston, TX

p. 113: *Flying Pancake* (on torso)
Taj Lucas Agate Briggles
(model)
Robert Damian Vaccarelli
(designer)
Tom Yak (tattoo artist)
Sally Hall (photographer)

p. 115: JJ from the TV show,
Good Times (on leg)
Kevin Rarick (model)
Ty Pallotta (tattoo artist),
Premium Blend Tattooing,
Manahawkin, NJ

p. 117: Hangman (on neck)
Alexandre Fedorintchik (model)

pp. 118–119: *Connect-the-dots*
(on leg)
Colleen AF Venable (model)
Dave C. Wallin (tattoo artist)
Chris Morran (photographer)

p. 120: Designer chairs (on arms)
Ahmad Fahkry (model)

p. 121: Eames lounge chair
(on arm)
Nick Baxter (tattoo artist/
photographer)
www.nickbaxter.com

pp. 122–123: Sewing machine
(on arm)
Helen J. Carter (model)
Stacey Martin (tattoo artist)

p. 125: Tramp stamp
(on lower back)
David Burch (model)
Billy Toler (tattoo artist),
Cherry Bomb Tattoos,
New Port Richey, FL

pp. 126–127: *I Love _____*
(on arm)
David J. Ores, MD,
aka "Dr. Dave" (model)
Greg Irikura (photographer)

p. 128: *Fat Elvis* (on arm)
Gabriel "Gabby" Moore
(tattoo artist),
Marked 4 Life, York, PA

p. 129: Elvis
Stephanie (tattoo artist),
I ov Thee Dragon, Racine, WI

p. 130: Plumber's butt, literally
(lower back)
Jim Maxon (model)
Annette Maxon (photographer)

pp. 132–133: Gunbelt
(around waist)
Melissa Nolan (model)
Steven Huie (tattoo artist),
Flyrite Tattoo, Brooklyn, NY

p. 134: *Two-faced* (on head)
Jim Jinx (model)
PJ Chmiel (photographer)

pp. 136–137: Peg leg
A. J. Goldman (model)
Evan Lovett (tattoo artist),
Twisted Visions Tattoo,
Clementon, NJ

p. 138: NYC tattoo removal
on motorcycle
Verena von Holtum
(photographer)

Front cover: *Two-faced* (on head)
Jim Jinx (model)
PJ Chmiel (photographer)

Back cover: Plumber's butt,
literally (lower back)
Jim Maxon (model)
Annette Maxon (photographer)

©2008 teNeues Verlag GmbH & Co. KG, Kempen
All rights reserved.

Edited by Verena von Holtum, Maria Regina Madarang, Christina Burns
Design by Allison Stern
Introduction by Seamus Mullarkey
Translations by Geneva Worldwide

Published by teNeues Publishing Group

teNeues Verlag GmbH + Co. KG
Am Selder 37, 47906 Kempen, Germany
Phone: 0049-(0)2152-916-0, Fax: 0049-(0)2152-916-111
e-mail: books@teneues.de
Press department: Andrea Rehn
Phone: 0049-(0)2152-916-202
e-mail: arehn@teneues.de

teNeues Publishing Company
16 West 22nd Street, New York, N.Y. 10010, USA
Phone: 001-212-627-9090, Fax: 001-212-627-9511

teNeues Publishing UK Ltd.
P.O. Box 402, West Byfleet, KT14 7ZF, Great Britain
Phone: 0044-(0)1932-4035-09, Fax: 0044-(0)1932-4035-14

teNeues France S.A.R.L.
93, rue Bannier, 45000 Orléans, France
Phone: 0033-(0)2-3854-1071, Fax: 0033-(0)2-3862-5340

www.teneues.com

ISBN 978-3-8327-9280-0

Printed in China

Bibliographic information published by Die Deutsche Bibliothek. Die Deutsche Bibliothek lists this publication
in the Deutsche Nationalbibliografie; detailed bibliographic data is available on the Internet at http://dnb.ddb.de.

teNeues Publishing Group
Kempen
Düsseldorf
Hamburg
London
Munich
New York
Paris

teNeues